DIANE LOVEJOY

CAT
LADY
CHIC

Abrams Image, New York

BY Diane Lovejoy

When I first realized I was heading rapidly down the road to becoming a Cat Lady, I did not have my full wits about me. I guess you could say I was rather naive, as I had not foreseen that this road would resemble a minefield, and that navigating it would require me to develop a thicker skin. Because I was entirely comfortable thinking of myself as a Cat Lady, I was unprepared for the onslaught of invective and mean-girl insults that would rise to the surface at any moment.

Still, I knew I loved cats dearly, and that was all that mattered. To me, *Cat Lady* was an auspicious nickname, and I never failed to respond whenever called. In fact, Cat Lady became my clarion call to action.

I suspect that I initially bored my friends, colleagues, and family members with my endless monologues about the joys of caring for multiple cats. At one point in time, I lived with a group of ten: Lucius, Lydia, Lillie, Leo, Linus, LB, TJ, Perkins, Miss Tommie, and Alvar. Invariably, the most vocal naysayers among the people I knew would interrupt me to ask, "Got it, but are you on board with the *image* that the Cat Lady brings to mind?" Cue the ominous organ music that accompanies a silent horror film, because the Cat Lady cometh.

I wondered increasingly about the conventional unflattering image of the Cat Lady. Did a crazed scientist invent her? Did she materialize as the figment of a writer's fertile imagination? Was she a composite figure put together by a traumatized sociologist? I longed for the authentic Cat Lady to please stand up.

The cultural image of the Cat Lady runs deep, to the extent that she could serve as the "un"-woman's ambassador. Have you noticed how often the negative prefix *un-* is attached to so many adjectives describing the Cat Lady? She is perceived as an unsightly woman: unkempt, unfashionable—hardly a style maverick. The Cat Lady is typically unmarried, "always the bridesmaid, never the bride." Put bluntly, the Cat Lady is woefully alone, a borderline hermit who comes unhinged easily but gets quickly into her comfort zone when she feeds stray cats. Cat Ladies may require a room of their own, one to share with their presumed hordes of felines. But, for supposedly obvious reasons, Cat Ladies do not need man caves in their homes.

The common assumption is that, because the Cat Lady lives without a man or a child, her colonies of cats fill a vast void. Clearly, the odds are stacked against the Cat Lady, who might as well have joined the ranks of the witches, trolls, and hags who inhabit the fanciful tales collected by the Brothers Grimm.

And then there is the *Crazy Cat Lady*, who is the butt of simplistic jokes and a recurring figure in syndicated comic strips, but a role model to many who appreciate, as I do, that women who are crazy for cats are probably not so different in their psychological makeup from men who are rabid sports fans. C'mon, Cat Ladies, don't we deserve to be on a level playing field with rowdy guys? Fervent passions and slightly eccentric obsessions keep life interesting and unpredictable. Nonetheless, it admittedly takes some fancy footwork to dance around the triple negative of Crazy Cat Lady, and I cringe when I hear those three words. In fact, most of my friends who are Cat Ladies bristle at the characterization.

I knew from the get-go that I did not fit neatly inside the frame that has come to box in the Cat Lady of lore (and yore). When I adopted my first stray cat, Lucius, more than fourteen years ago, I had already been happily married to my husband, Michael, for twelve years. And while my career as an editor of museum publications and art books has never been accompanied by a salary that permits me to shop at Chanel and other high-style emporiums, I was always pleased to be complimented on my wardrobe choices. I was a married and fashion-loving career woman who was not embarrassed to disclose her love affair with felines. I liked being utterly Cat Ladylike.

While I was rescuing cats—seventeen during four bliss-filled, albeit logistically challenging, years—and each one was revealing to me something new about myself, I became determined to rescue the Cat Lady from the Hall of Shame. I was eager to overturn the indictment against the Cat Lady, motivated by the maxim "A woman's work is never done." Yet a funny thing happened along the way on my myth-debunking mission. In spite of the derogatory image of the Cat Lady, I discovered a treasure trove of diverse images depicting chic Cat Ladies.

I questioned seriously why anyone could think that *Cat Lady chic* is an oxymoron. Not even close. My "recovery" work was going to be easier than I had anticipated. To my great

delight, the chic Cat Lady was ever present. As indisputably as cats have nine lives, Cat Ladies throughout history have dressed to the nines.

My visually driven expedition has led me to artists' and photographers' archives, where I was struck repeatedly by the convergence of the "wow" and "meow" factors. Glitz! Glamour! Allure! Cat Ladies are beautiful people, too, on the right side of the velvet ropes that serve as lines of demarcation in what has forever been an image-conscious world. You either are a member of the club or you are not.

I have it on authority that the Cat Lady is "in." Granted, photographers are masters of artifice and sleight of hand, and I cannot overlook the fact that many of the images I have selected for this book were staged by photographers with specific female muses (and kitty quotas) in mind. A purist might argue that my handpicked images are manufactured, too. I am willing to concede that point. Yet the pictures gathered here collectively challenge the convenient, ultimately damaging image of the Cat Lady that has permeated society for far too long. I should also note that the images of chic Cat Ladies do not represent the "after" versions of the "before-and-after" transformations of women that are published regularly in fashion magazines. The camera focused on the Cat Lady does not lie: these superbly photogenic ladies did not go under the Photoshop knife, so to speak, to emerge in pictures with cats. In many cases, because of their classic beauty, the Cat Ladies were born chic. In other cases, chic can be defined as an empowering state of mind.

Artists throughout history have presented an equally attractive Cat Lady—a woman who is poised, put-together, and supremely confident. Beauty is indeed skin-deep as well as in the eyes of the beholders—not only we Cat Ladies, drawn to admire our predecessors and contemporaries, but also the cats themselves shown in the images. They are lucky creatures, assigned to front-row seats with their chic Cat Ladies.

In each instance, I believe that the woman who was photographed or painted or sketched assumes an additional aura—let's call it the *Cat Lady halo effect*—because of the cat who is tucked beside her or rests at her feet, or who cuddles comfortably on her lap, or who is draped around her neck as grandly as an Hermès silk scarf. The images also

show fascinating resonances and kinships across the board: there are similar graceful gestures and positions to note among the ladies and cats. Elegant women cradle elegant cats. Savvy cats attract sophisticated ladies. In several photographs, Cat Ladies sweep their cats off the ground to meet their gaze, and they are virtually dancing cheek to cheek (or chic to chic).

Cats are notoriously fastidious creatures who like to preen and to be praised, if not worshipped, for their perfection. So it is only fitting that photographers and artists have frequently paired felines with irresistibly chic women who are accustomed to being admired.

Speaking of beauty, I am a Cat Lady who believes that all cats are beautiful, no matter their age, shape, or size—from tortoiseshells to tabbies, from calicoes to Maine coons. Black cats also have their day in court in this book. No more superstitions, evil curses, and bad luck accompany these sleek felines, several of whom resemble miniature panthers. Lauren Bacall, Carole Lombard, and Carla Bruni-Sarkozy are among the notable women proudly holding black cats. And long before selfies and the now-ubiquitous kissy-face, photographer Dora Kallmus made a striking self-portrait that incorporates the kitty face of a black beauty.

Researching images of chic Cat Ladies amounted to an exhilarating creative exercise. I began to fantasize about building a Cat Lady empire populated by a bevy of chic women with their cats. I have never suffered from extreme anxiety about being branded a Cat Lady, so why not buff, polish, and refurbish the Cat Lady brand? In my new world order, the Cat Lady brand will be identified instantly by its interlocking *CL* letters. The monogram must be specified in a stylish font, and there will be no scarlet letters pinned to the chests of Cat Ladies. I envision this monogram on a classic houndstooth tailored jacket. I must consult with Ralph Lauren, who knows a thing or two about premium global brands and Harris tweed.

As I was admiring images that document the chic Cat Lady, I started classifying them according to my own themes. I formed a group consisting of picture-perfect Cat Ladies who dress smartly and accessorize appropriately for their time, whether in an Egyptian,

exotic, floor-length gown that could be a precursor of apparel designed by Etro, or in a sumptuously colored Renaissance robe with complementary turban-style headwear, or in Pre-Raphaelite diaphanous clothing. There is also the redheaded beauty whose cultured pearl necklace doubles as a cat toy, and one of the arbiters of twentieth-century interior design, Elsie de Wolfe (Lady Mendl), wearing white gloves as she holds two cats and, undoubtedly, provides white-glove service to them. Surely all these cats approved of their ladies' sartorial splendor as demonstrated from head to toe.

At the opposite end of the spectrum are the Cat Ladies who wear no clothes while in the company of cats and, by default, do not appear on the annual international best-dressed list. One of the head-turning images I found is, per the artist, intended to be an allegory of music. May I suggest that this painting is all about a multitasking Cat Lady: she is naked, holding a musical book in one hand and a viola in the other. A hefty white cat stands guard. We Cat Ladies know all about juggling responsibilities 24/7. Who needs allegories? More intriguingly, what is it about cats that prompts some women to lounge or daydream in the buff with them? The stark-naked Cat Ladies pictured in this book got out of their prover-bial straitjackets and slipped into something much more comfortable. Perhaps they are cut from the same uninhibited cloth, or their sense of self is so assured that they manage to look stylish without wearing a stitch.

A variation on the undressed theme is the seductive photograph showing Ann Sher-idan wearing peekaboo lace—an image that stares down the stereotype of the frumpy, disheveled Cat Lady in a frayed bathrobe. Animal magnetism works both ways, from kitties to It girls. By the way, did you know that Ursula Andress, the first Bond girl, is a Cat Lady?

Posing regally, and fully clothed, has been de rigueur for the legendary female stars of the silver screen. I gravitated toward images of some of Hollywood's leading ladies, lured by their exquisiteness and charmed by their feline companions. Lights, camera, Cat Lady! I can almost hear the E! Entertainment correspondents chatting excitedly with one another: "*Who* is the Cat Lady wearing?"

If only I could look like Dolores del Rio, who cut a ravishing figure and radiated high-wattage style. The Mexican-born actress, who began her career during the silent era, was considered to be the personification of beauty in Latin America, and her glamour resonated worldwide. Here, Miss del Rio is impeccably coiffed, her wavy black hair artfully framing her face. The movie star snuggles with her black cat, Joan, and it appears they are settling in together to spend a cozy evening by a roaring fire. I imagine that Joan was mesmerized by her beguiling Cat Lady.

Like many women, I have fantasized that one day—and this requires a leap of faith—I will awaken and bear an uncanny resemblance to Audrey Hepburn. Long before I became a Cat Lady, I was introduced by my parents to Miss Hepburn's films and ranked *Breakfast at Tiffany's* as my favorite, for several reasons. I had New York City in my blood (on my father's side), I owned some affordable silver trinkets from Tiffany's, and I wanted the Givenchy black dress that the character Holly Golightly wears in the unforgettable opening scene of the film. I confess to collecting black dresses, despite their propensity for revealing cat hair (and every Cat Lady carries a pocket-size lint brush, anyway).

Since becoming a Cat Lady, I have watched *Breakfast at Tiffany's* with sustained interest because I focus on Holly's interactions with her officially unnamed ginger "Cat." I've forgiven Holly for not being a super-attentive, empathetic Cat Lady in the beginning of the film. Given her all-nighter lifestyle, it's understandable that she opts for cocktails and foie gras over dispensing Friskies. But Holly makes up for lost time in the end when she rescues "Cat" from the rain-soaked alleyways of New York. She does so flawlessly in a light-beige Burberry trench coat. Audrey Hepburn as Holly Golightly is an impossibly chic Cat Lady whose style I aspire to emulate.

I also have long been fascinated by the delicate loveliness of Vivien Leigh. One of my great-aunts was a gossip columnist for the *Hollywood Reporter*, and she and Miss Leigh became fast friends upon their introduction in the late 1930s. I treasure an autographed letter of Miss Leigh's from the 1960s that I inherited from my aunt, for this faded piece of stationery—with the salutation "Radie, Darling"—connects me to the woman who, in my

mind, is everlastingly Scarlett O'Hara. All along, in real life Miss Scarlett was yet another passionate woman who adored felines, and she was photographed with her Siamese cats on numerous occasions.

If I were organizing a chick-flick festival for Cat Ladies, *Bell, Book, and Candle* would take top billing. Kim Novak plays Gil Holroyd, a va-va-voom chic art gallery owner and modern-day witch who has a codependent relationship with her "familiar," Pyewacket. And what Cat Lady fashionista does not covet the reversible leopard print–lined cape and Jean Louis gowns that Gil wears with unmistakable panache?

Come to think of it, leopard has always been in vogue. I'm sure you have noticed it can be a jungle out there, which could explain why fashion designers never retire their feline-inspired attire from the runways. I bet that if your wardrobe includes anything with leopard, your need for Cat Lady verification will be bypassed at the front door.

French-born Cat Ladies are an exceptionally fashionable breed. They have that inimitable je ne sais quoi in spades. The photographs in this book of Brigitte Bardot, Juliette Gréco, and Jeanne Moreau, among others, prove that *meow* is *très chic*.

Whenever I think of Grace Kelly, one image stands out. That is why images are so powerful—once they are etched indelibly in our memories, they do not recede easily. I see Miss Kelly as the beatific bride who glides down the aisle of a historic church to become the princess of Monaco. I smiled when I happened upon the glorious image of Grace Kelly with a tabby kitten, and this feline must have been ecstatic to be held closely by the serenely chic star.

While selecting images for this book, I learned of a rare photograph of Marilyn Monroe that had surfaced. Robert Vose, who snapped the picture of Grace Kelly, also took the magical photograph of Miss Monroe with her kitten, Serafina, during the filming of *Let's Make Love*. It would be difficult to top hearing "Here, kitty" in the whispery voice of Marilyn Monroe, who proved that Cat Ladies and sex kittens can be mentioned in the same breath.

Cat Ladies instinctively know the ideal tone of voice to use to coax and pacify their cats. I never knew that cats had benefited from hearing Jacqueline Bouvier Kennedy Onassis's

memorably breathy voice. Of the countless images of Jackie O, the ultimate style icon in my personal scrapbook, I am particularly fond of the one I found of her before she became First Lady. Mrs. Kennedy sits majestically, like a mama kitty on duty, watching protectively over her daughter, Caroline, and two cats.

I also associate Jackie O with celebrating the highest expressions of creativity. Just as the First Lady ushered into the White House a new standard for culture and refinement, I have dreamed of becoming the standard-bearer for Cat Lady culture. Imagine the eclectic soirées attended by artists and entrepreneurs, writers and models, singers and dancers—and their cats are invited, too. The decades dissolve, and I open my front door to greet my accomplished guests, including Tracey Emin, Leonor Fini, Georgia O'Keeffe, and Lauren Pears; Colette, Margaret Mitchell, and Veruschka; Lana Del Rey, Carrie Ann Inaba, and Diana Ross. Hillary Clinton drops by and delivers an impromptu speech, with a firing-up-the-base conclusion: "Let not the Cat Lady be obscured by type!" My favorite country-and-western crooner, Dolly Parton, is the last guest to arrive. She serenades us with her biggest *Billboard* hit, "I Will Always Love You," and every cat in the house laps it up.

To all the Cat Ladies in the world, the spotlight is yours, always. I am honored to present, in the following pages, eternally chic Cat Ladies who have come from across the globe to live on the same stage. I hope very much that my fellow Cat Ladies are enjoying their conversations with one another, and also laughing all the way. The joke is no longer on us.

So the next time someone says, with undisguised concern, "Oooh, you are *really* a Cat Lady," promise me that you will embrace your status and smile. We have every good reason to celebrate. The lookbook that is in your hands makes the case for our impressive lineage.

RIGHT: Kim Novak and Pyewacket, from the film *Bell, Book, and Candle*, 1958.

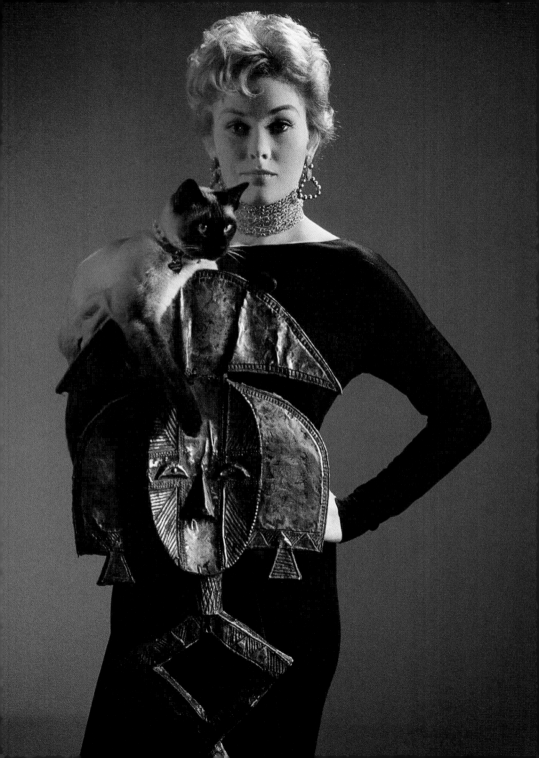

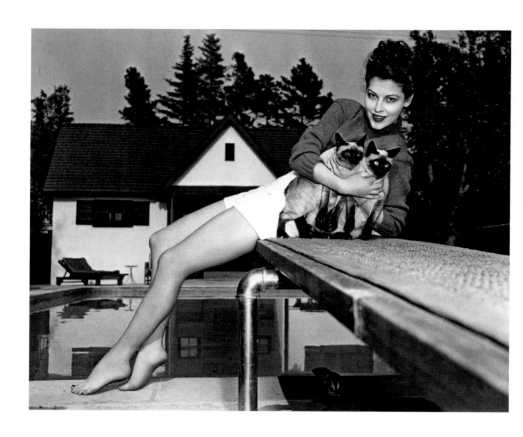

ABOVE: Ava Gardner and Siamese
cats, c. 1945.

RIGHT: Grace Kelly and kitten, on the
set of the film *To Catch a Thief*, 1954.
Photograph by Robert Vose.

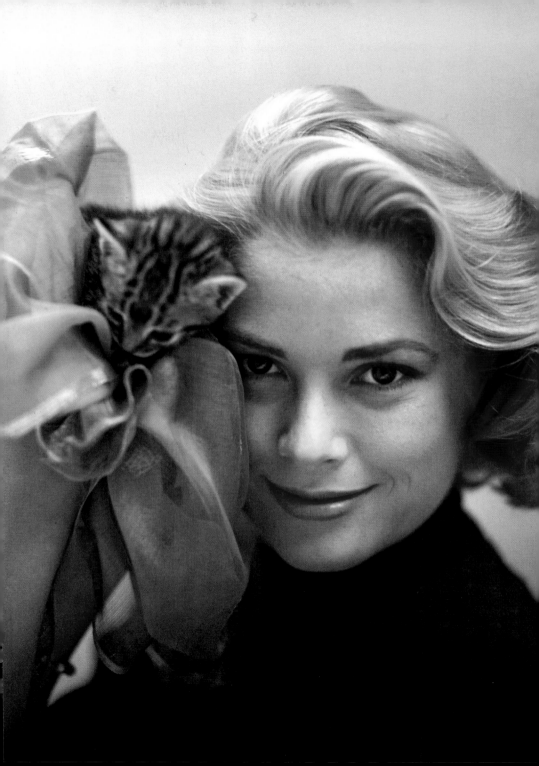

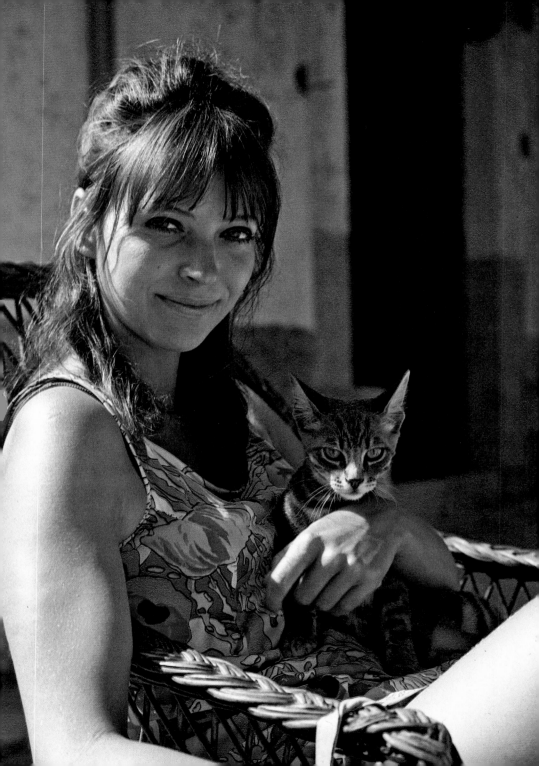

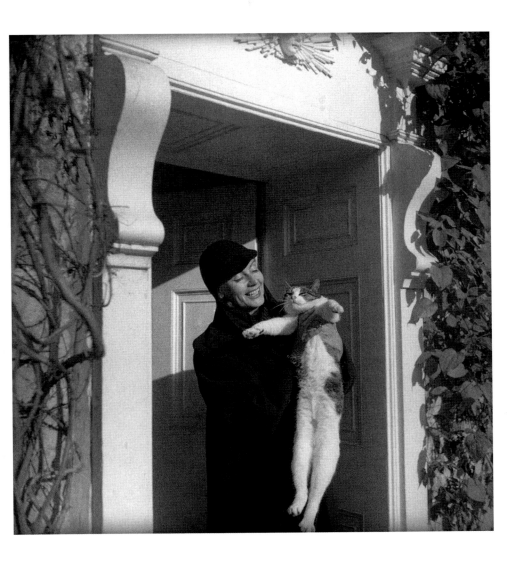

LEFT: Anna Karina and cat.

ABOVE: Greta Garbo with Cecil
Beaton's cat at his home, Reddish
House, in Broad Chalke, England,
1951. Photograph by Cecil Beaton.

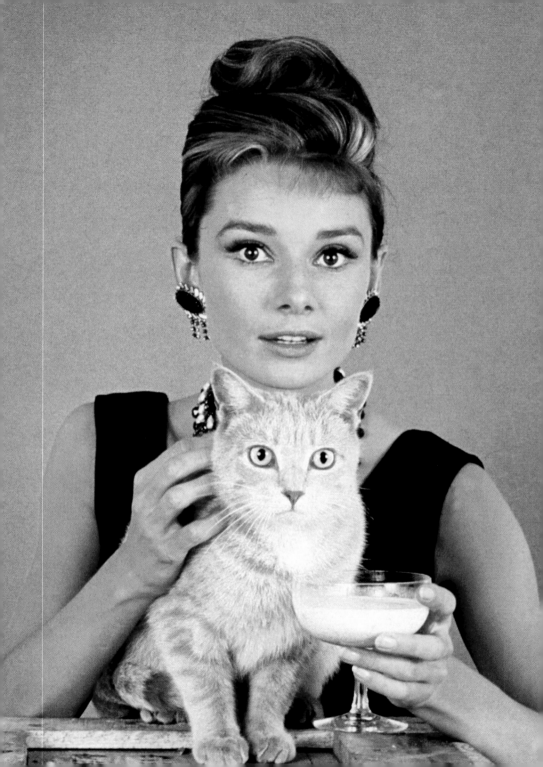

"YOU KNOW THOSE DAYS WHEN

YOU GET THE MEAN REDS? . . .

IF I COULD FIND A REAL-LIFE PLACE

THAT MADE ME FEEL LIKE TIFFANY'S,

THEN I'D BUY SOME FURNITURE

AND GIVE THE CAT A NAME."

—AUDREY HEPBURN AS HOLLY GOLIGHTLY
IN *BREAKFAST AT TIFFANY'S*

Audrey Hepburn and "Cat," from the film *Breakfast at Tiffany's*, 1961. Photograph by Howell Conant.

RIGHT: Sunny Harnett holding cat.
Photograph by John Rawlings.

BELOW: Mia Farrow and cat, 1967.

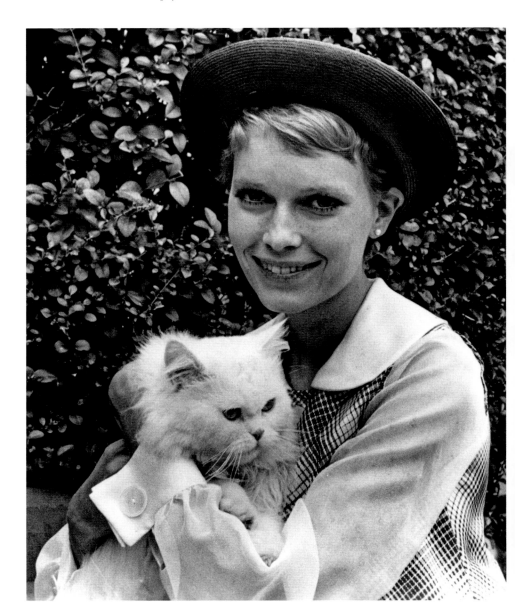

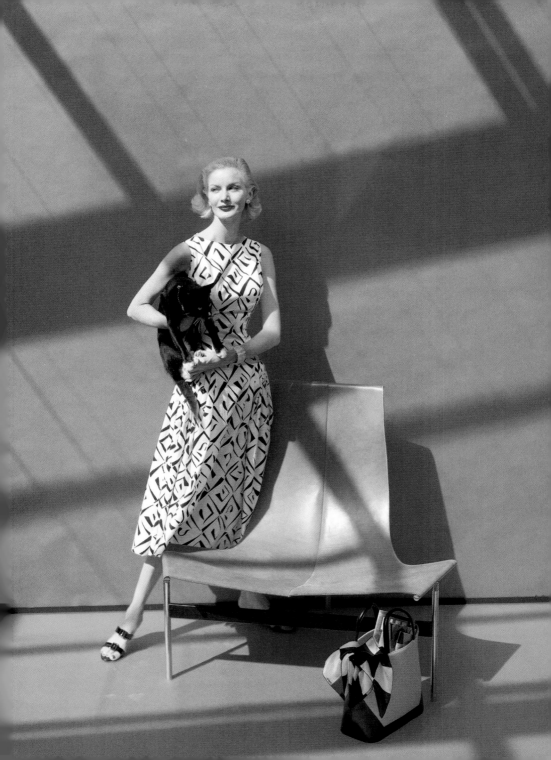

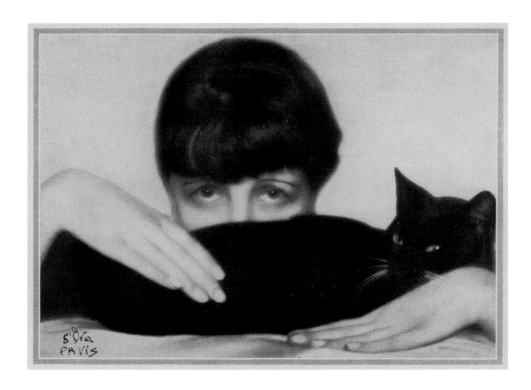

ABOVE: Dora Kallmus, Austrian,
1881–1963. *Madame d'Ora,
Self-Portrait*, Paris, c. 1925.

RIGHT: Gina Falckenberg and cat,
1937. Photograph by Imre von
Santho.

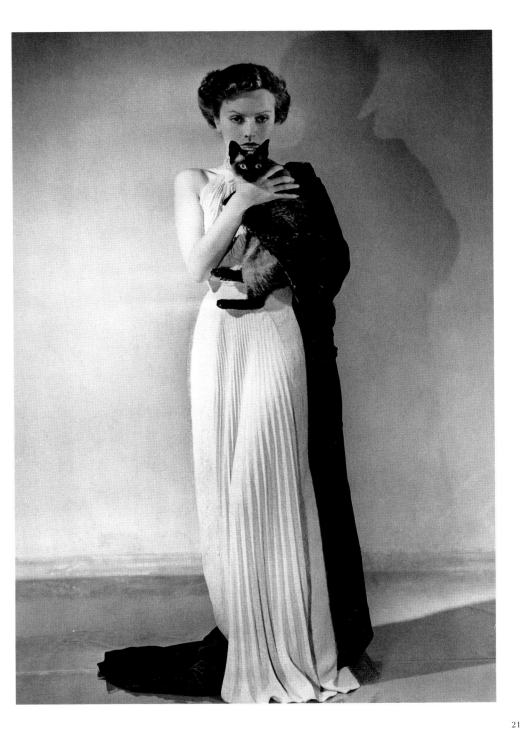

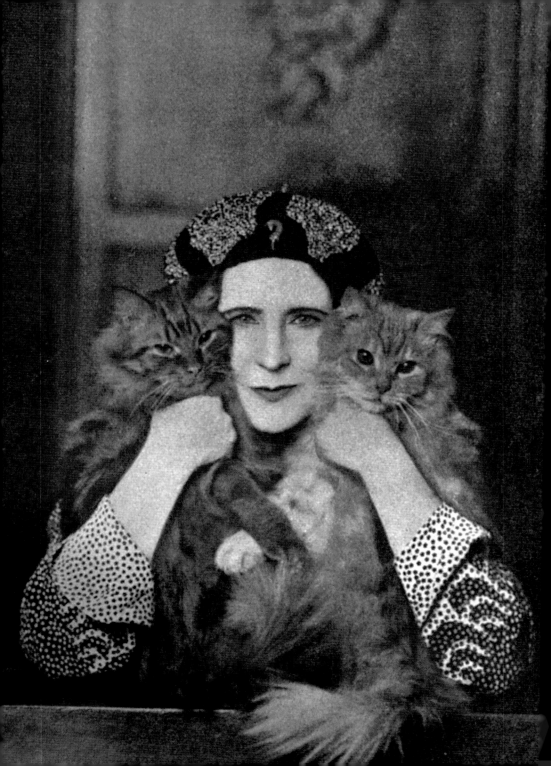

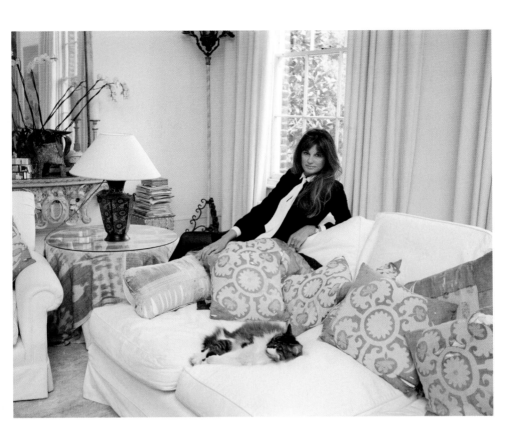

LEFT: Elinor Glyn and cats, 1932.

ABOVE: Jemima Khan and cat, 2013.

RIGHT: Elizabeth Taylor and her Siamese cat, 1956. Photograph by Sanford Roth.

BELOW: Diana Ross and cat, from the film *Mahogany*, 1975.

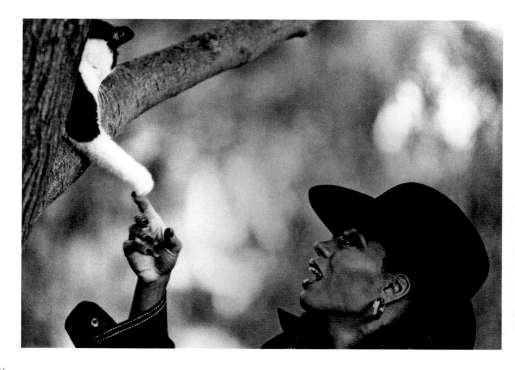

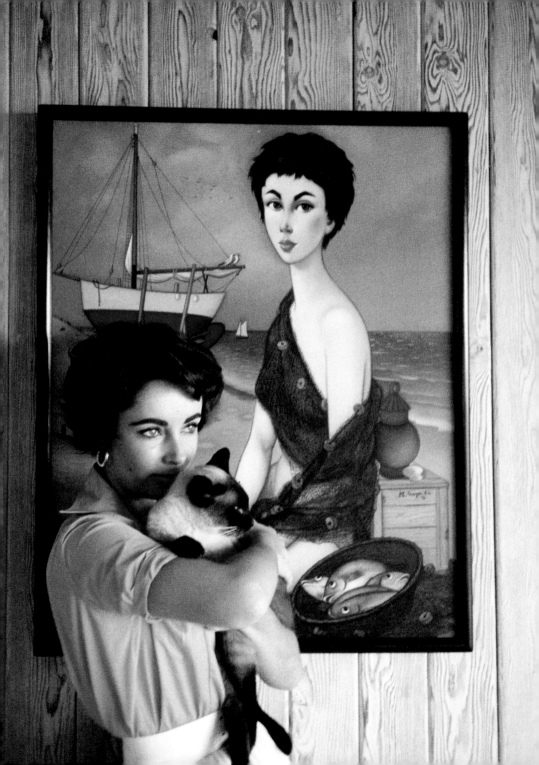

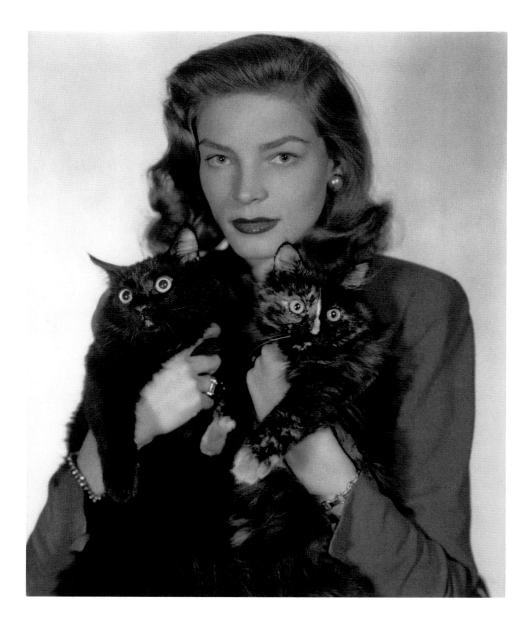

ABOVE: Lauren Bacall and cats, 1940s. RIGHT: Anita Louise holding cat,
c. 1936. Photograph by Lusha Nelson.

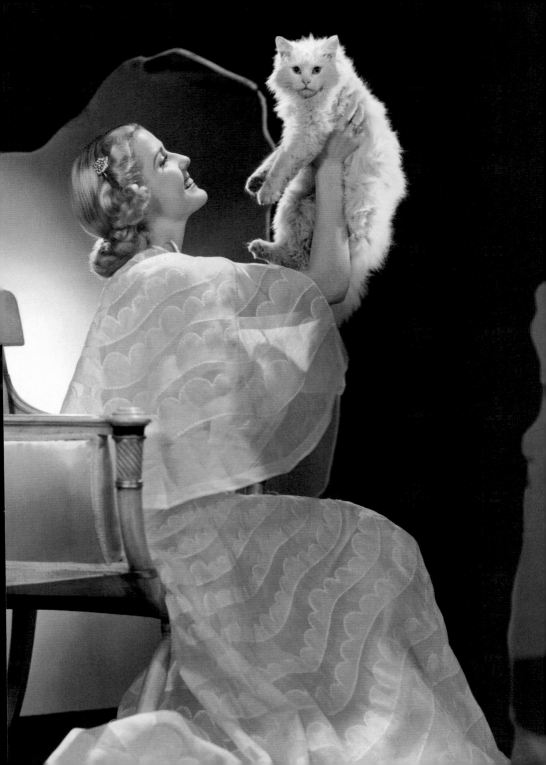

"I'M A CAT. YOU KNOW, CATS

DON'T LIKE TO GO OUTSIDE.

THEY ACTUALLY DROP THEIR SMELL

ALL OVER A PLACE, AND THAT

BECOMES THEIR PLACE. SO WHEN

YOU LIVE WITH A CAT, YOU ACTUALLY

LIVE AT THE CAT'S HOUSE."

— CARLA BRUNI-SARKOZY

Carla Bruni-Sarkozy and cat. Photograph by Guy Reno.

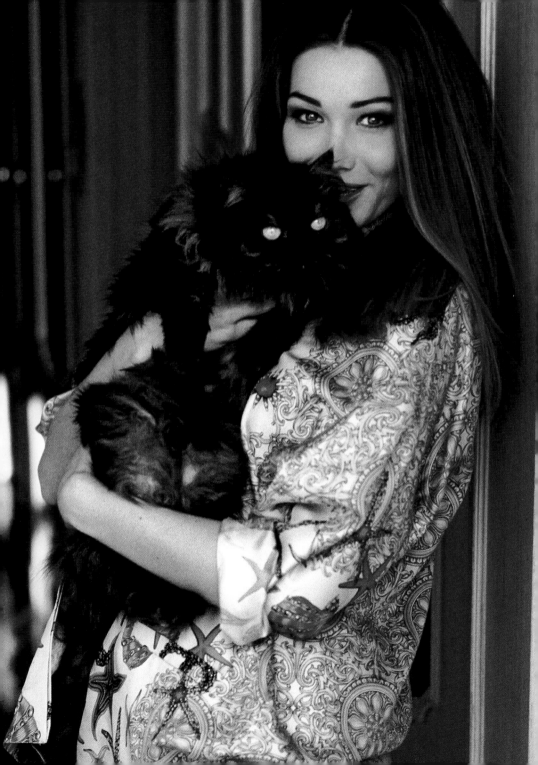

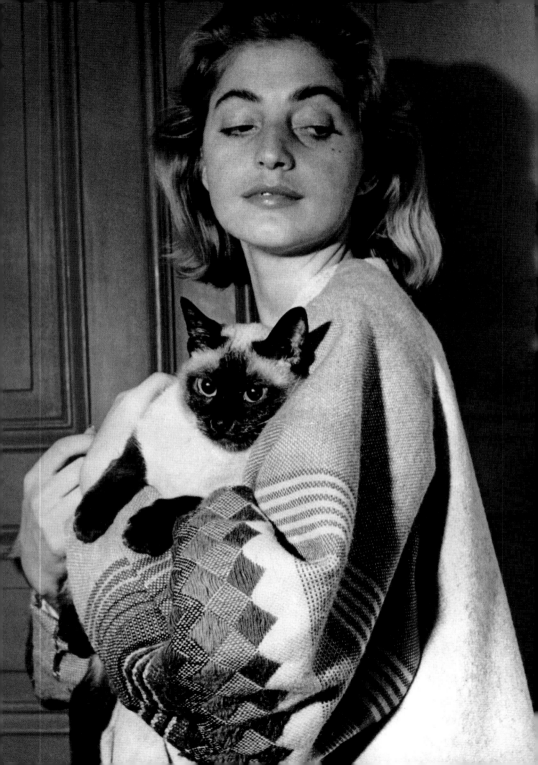

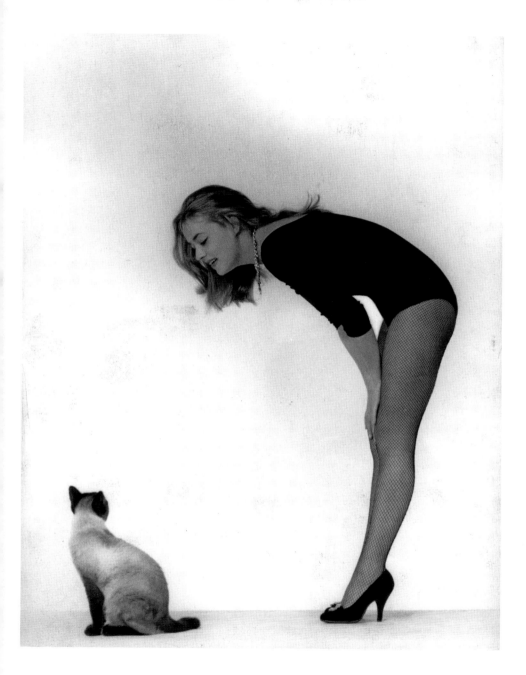

LEFT: Hjoerdis Hjalmarsdotter with
her cat, 1955.

ABOVE: Jeanne Moreau and cat.
Photograph by Sam Levin.

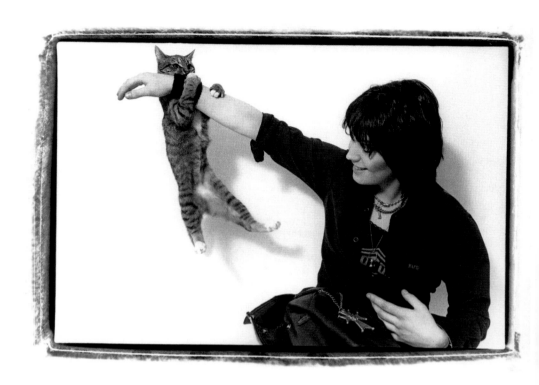

ABOVE: Joan Jett and Tchatchke,
New York City, 1981. Photograph by
Laura Levine.

RIGHT: Christopher Nevinson,
British, 1889–1946. *A Studio in
Montparnasse*, exhibited 1926,
oil on canvas.

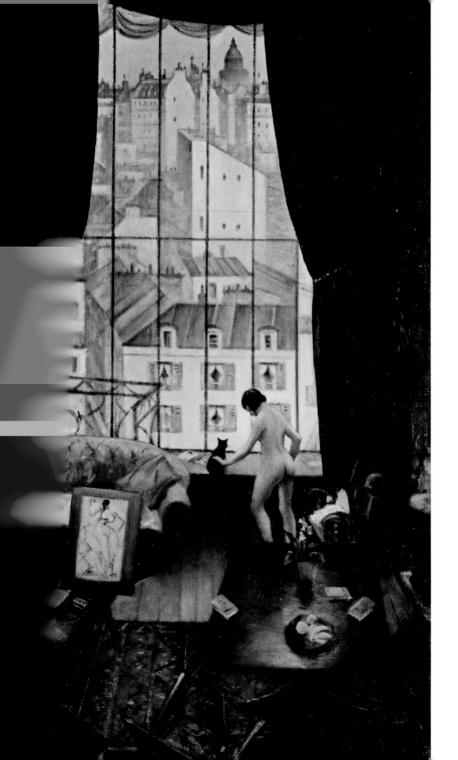

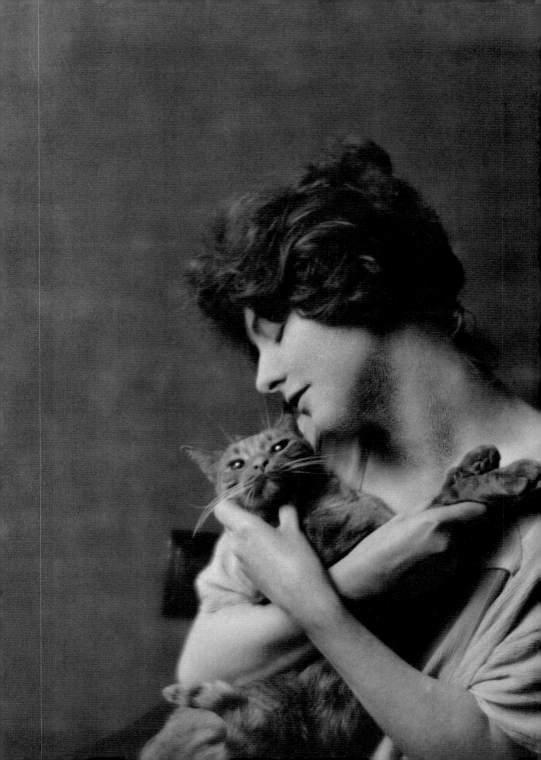

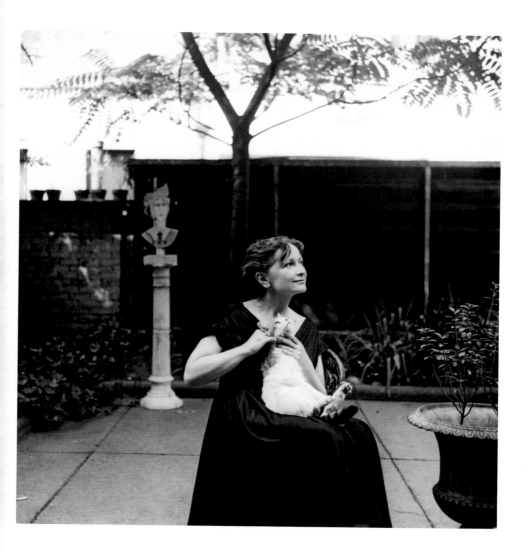

LEFT: *Miss Bermicchi with Buzzer the Cat*, 1916, glass negative. Photograph by Arnold Genthe.

ABOVE: Hedda Sterne and her cat, c. 1940. Photograph by Evelyn Hofer.

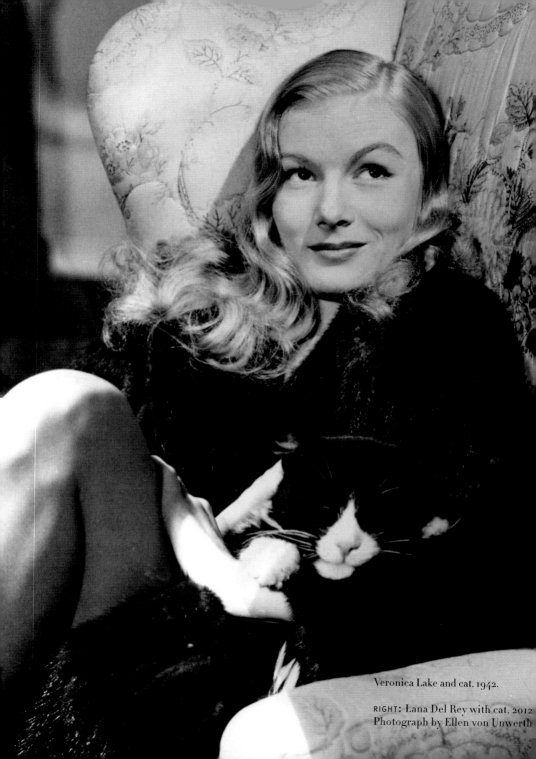

Veronica Lake and cat, 1942.

RIGHT: Lana Del Rey with cat, 2012
Photograph by Ellen von Unwerth

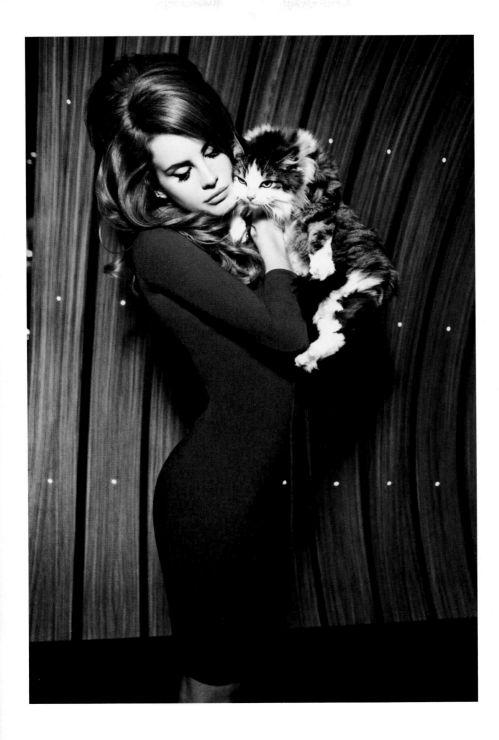

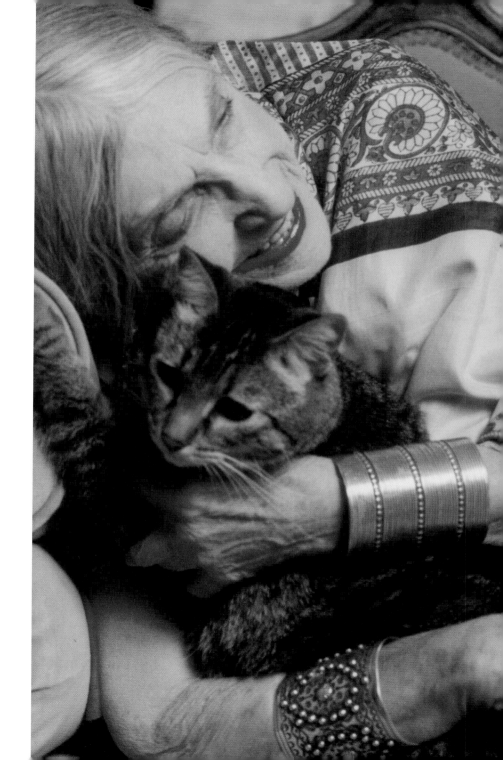

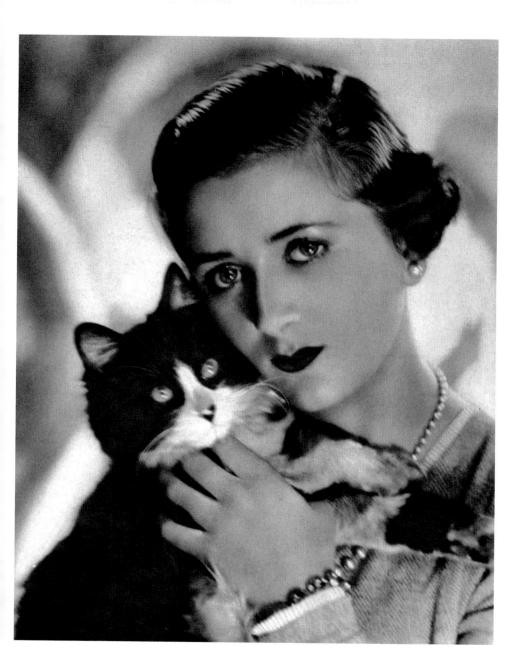

LEFT: *Dear Pussy* [portrait of Beatrice Wood], 1998, chromogenic print. Photograph by Marlene Wallace.

ABOVE: Lady Daphne Finch-Hatton and Whiskey, a cat who lived at the studio of "camera-artist" Madame Yevonde.

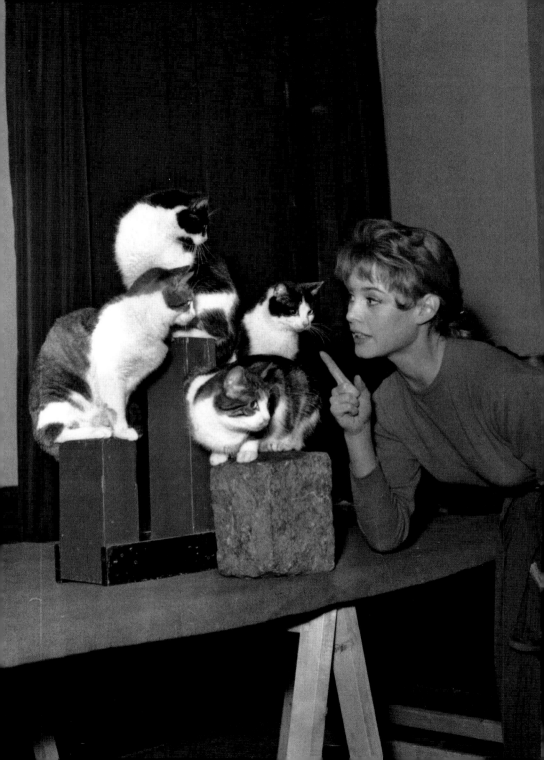

"I AM REALLY A CAT

TRANSFORMED INTO A WOMAN. . . .

I PURR. I SCRATCH.

AND SOMETIMES I BITE."

—BRIGITTE BARDOT

Brigitte Bardot with cats, 1956.

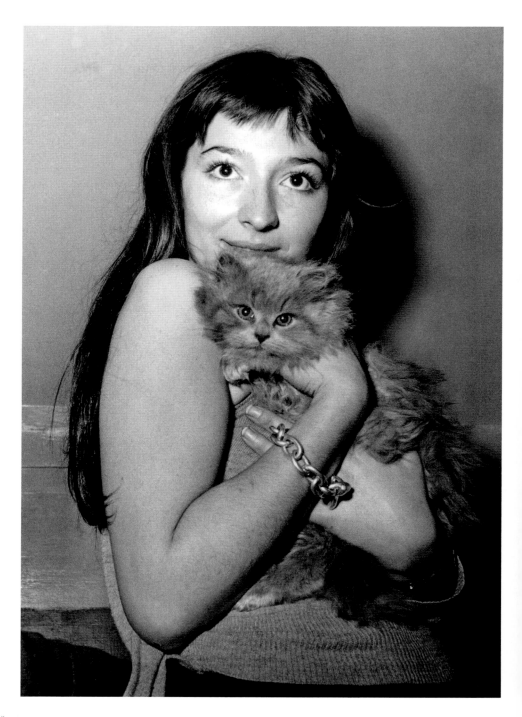

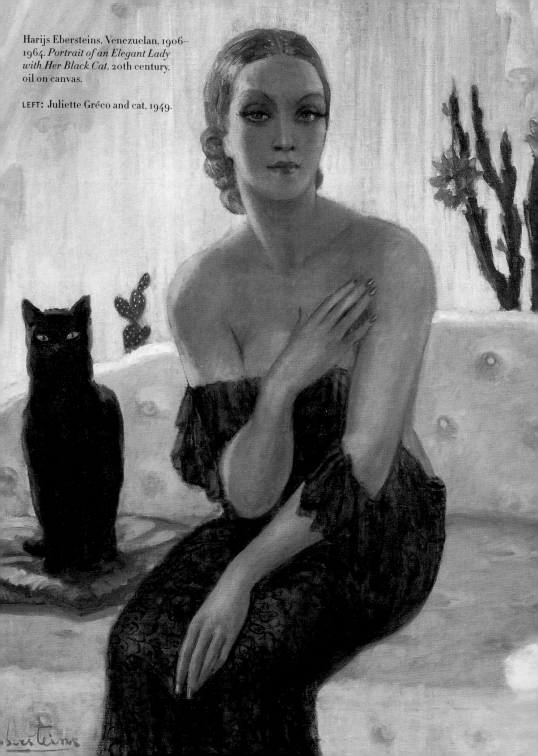

Harijs Ebersteins, Venezuelan, 1906–1964. *Portrait of an Elegant Lady with Her Black Cat*, 20th century, oil on canvas.

LEFT: Juliette Gréco and cat, 1949.

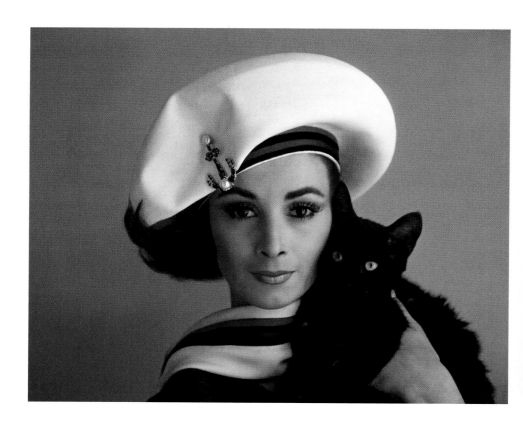

ABOVE: Wilhelmina Cooper and cat,
1962. Photograph by Karen Radkai.

RIGHT: Mary Astor and cat.
Photograph by Edward Steichen.

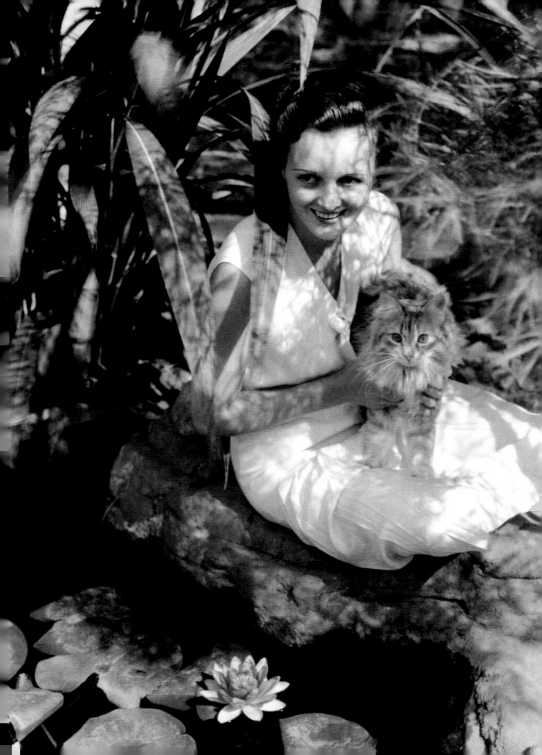

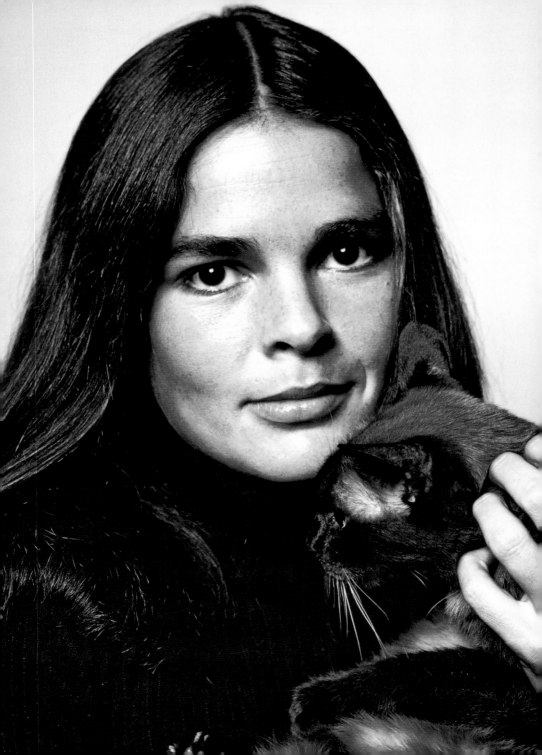

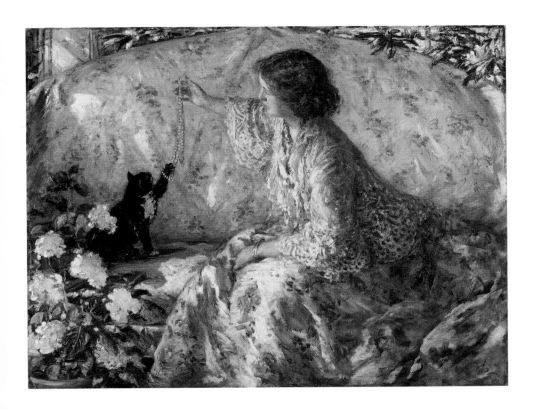

ABOVE: Philip Wilson Steer,
British, 1860–1942. *Hydrangeas*,
1901, oil on canvas.

LEFT: Ali MacGraw and cat,
from the film *Love Story*, 1970.

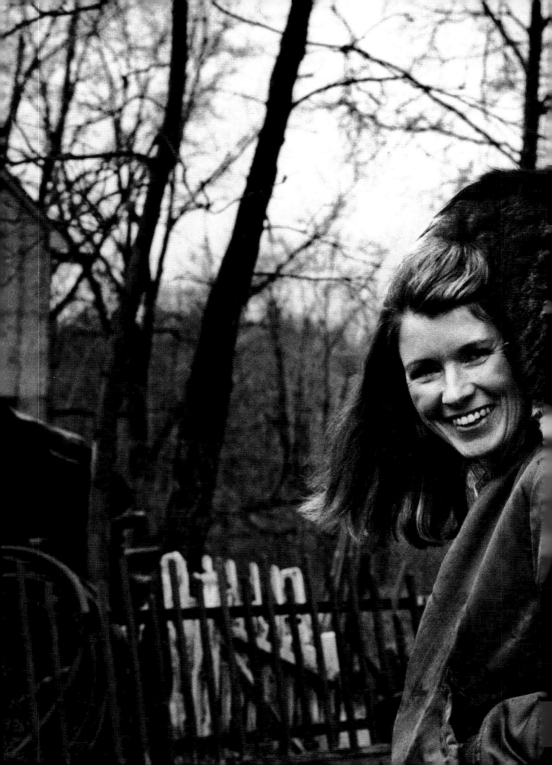

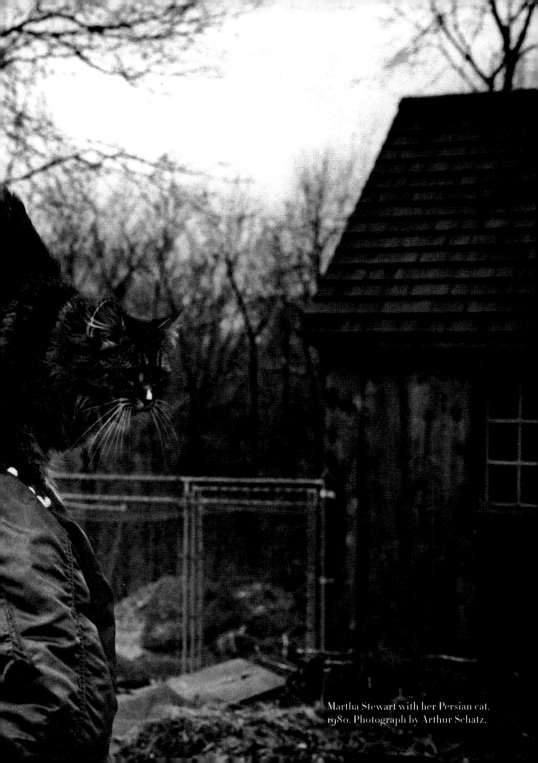

Martha Stewart with her Persian cat, 1980. Photograph by Arthur Schatz.

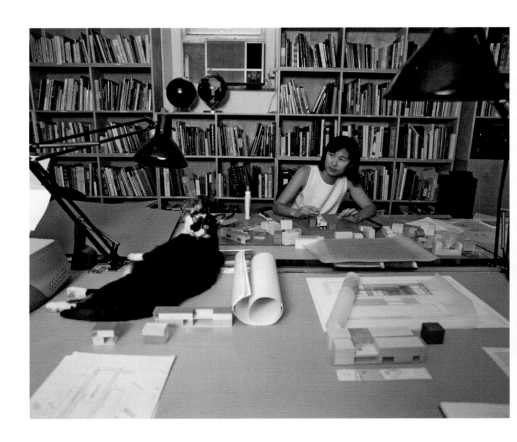

ABOVE: Maya Lin and cat, 2002.
Photograph by Enrico Ferorelli.

RIGHT: Katharine Hepburn and cats,
from the film *Little Women*, 1933.
Photograph by Henry Guttmann.

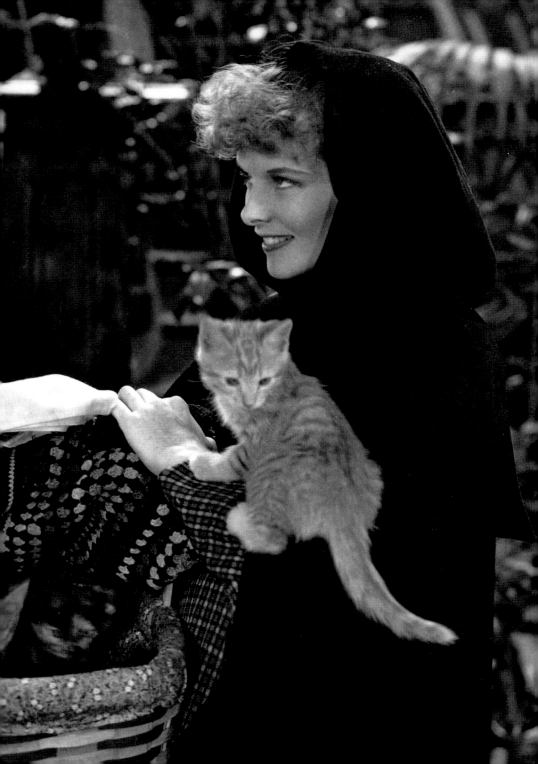

"BY ASSOCIATING WITH THE CAT,

ONE ONLY RISKS BECOMING RICHER."

– COLETTE

Colette and her cats, c. 1925–30.

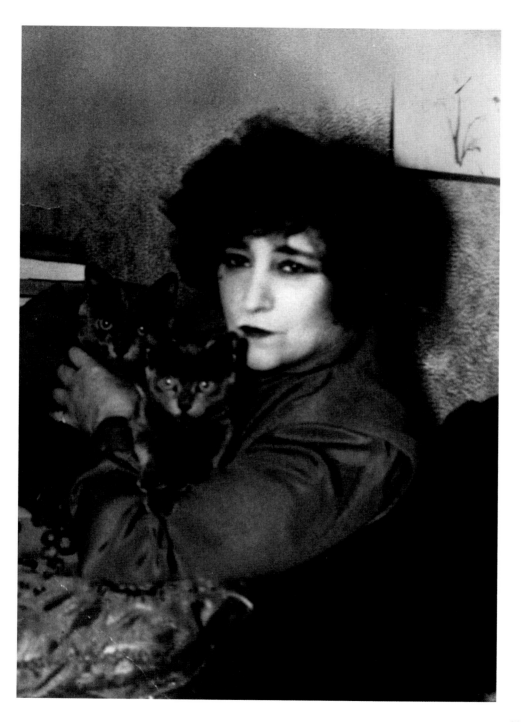

BELOW: Eva Longoria and cat during filming for Sheba in Beverly Hills, California, 2013. Photograph by Casey Rodgers.

RIGHT: Evelyn De Morgan, British, 1855–1919. *The Love Potion*, 1903, oil on canvas.

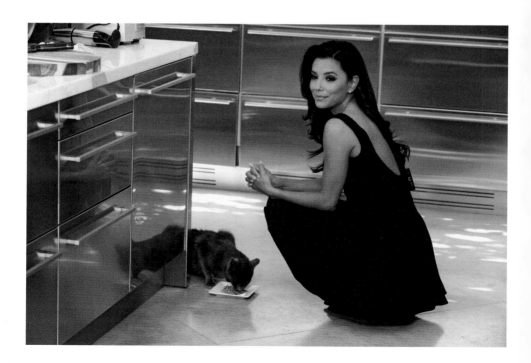

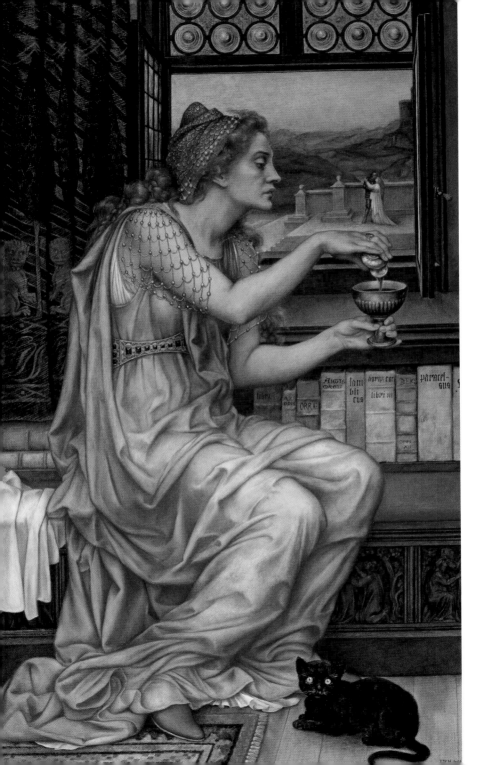

55

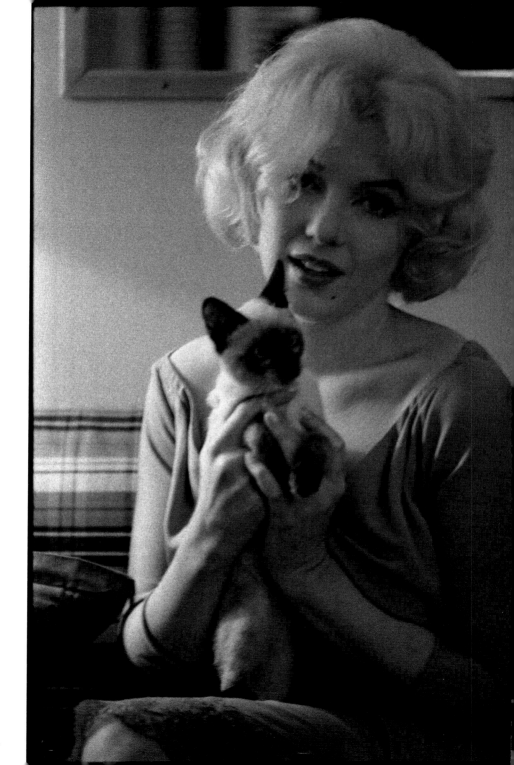

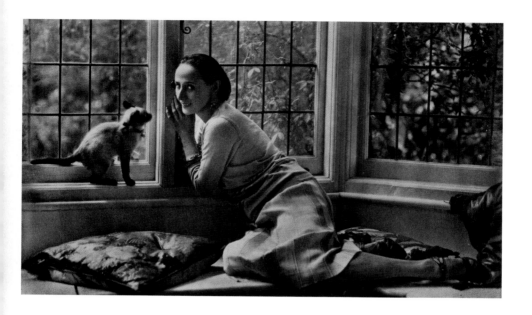

ABOVE: Anna Pavlova at home in London with her cat, c. 1920.

LEFT: Marilyn Monroe and her Siamese kitten, Serafina, 1960. Photograph by Robert Vose.

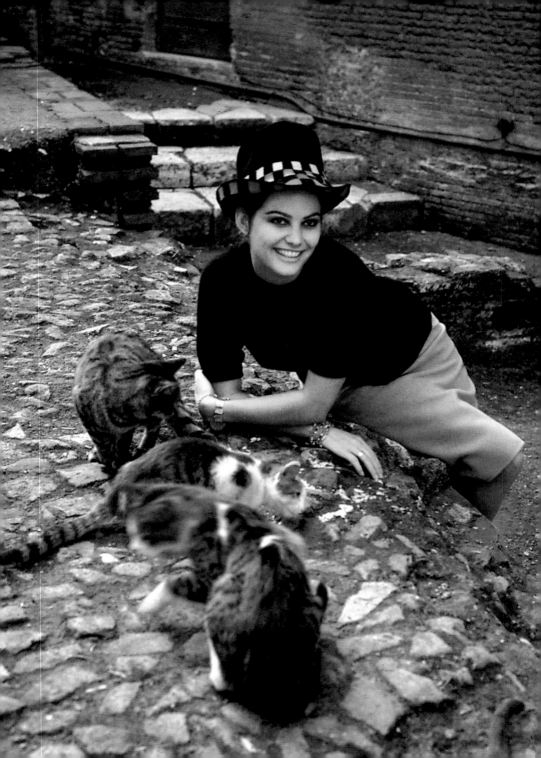

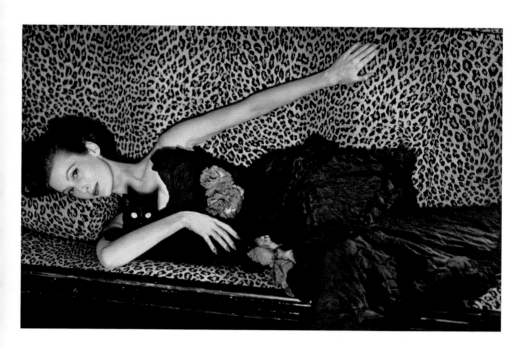

ABOVE: Mary Jane Russell and cat on
a leopard sofa, Paris, 1951.
Photograph by Louise Dahl-Wolfe.

LEFT: Claudia Cardinale and cats,
c. 1960s.

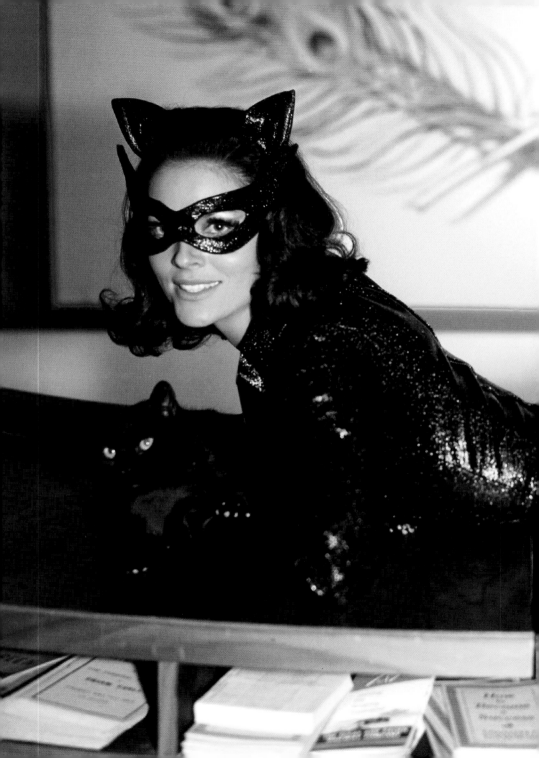

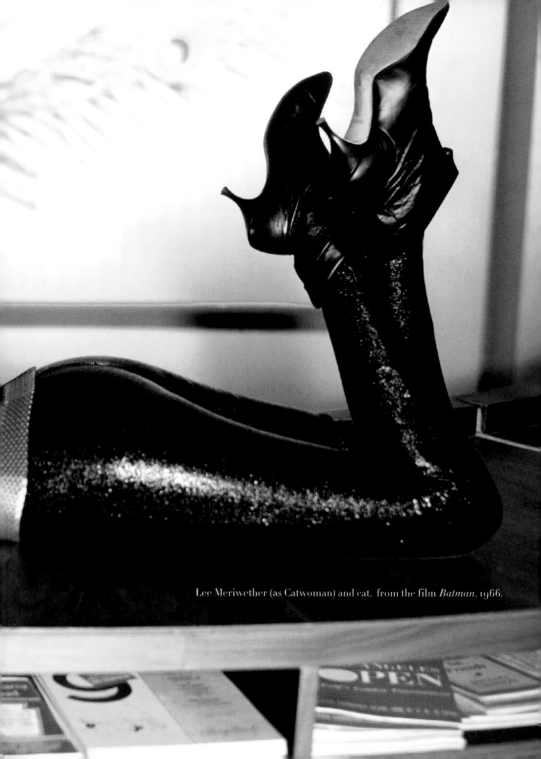

Lee Meriwether (as Catwoman) and cat, from the film *Batman*, 1966.

BELOW: Veruschka and a Siamese cat at the home of Brazilian writer Jorge Amado, c. 1968. Photograph by Franco Rubartelli.

RIGHT: Anja Silja with her cat, 1969. Photograph by Jochen Blume.

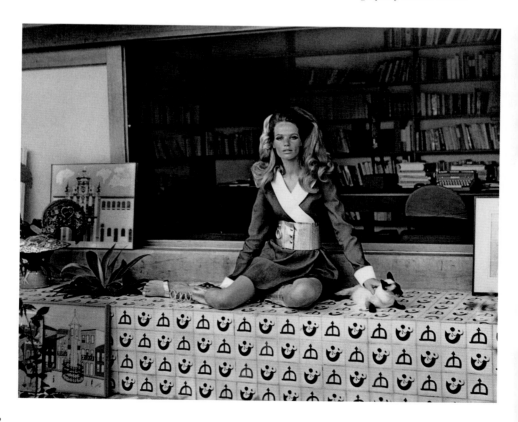

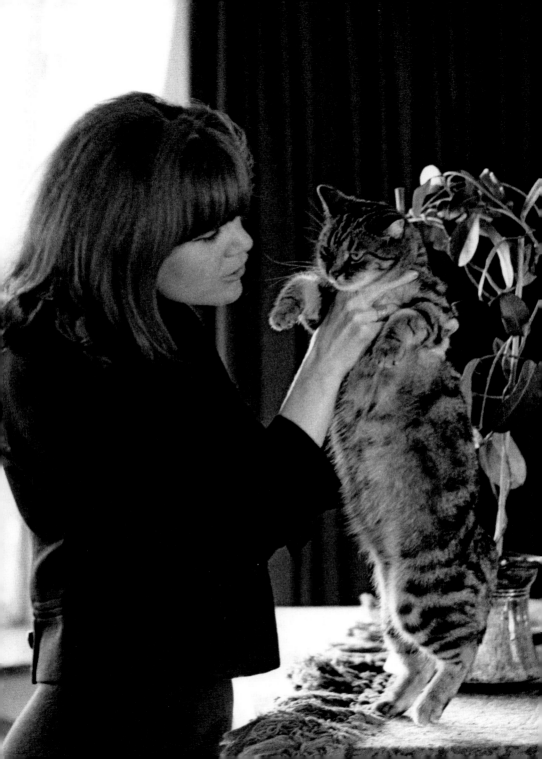

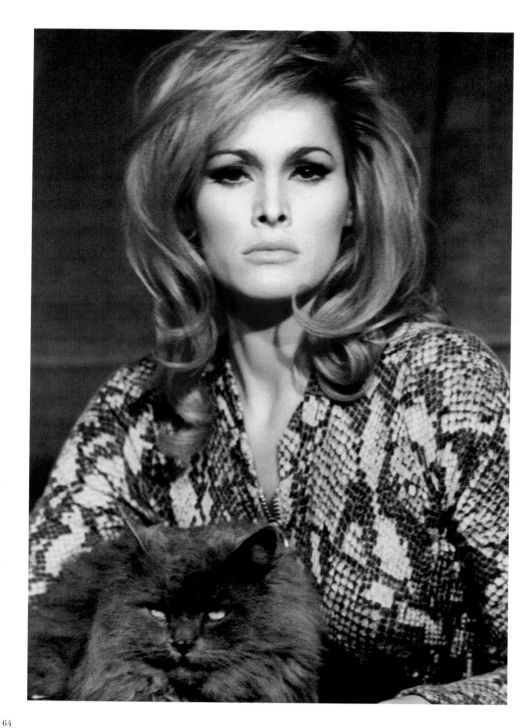

"I TAKE CARE OF MY FLOWERS

AND MY CATS. AND ENJOY FOOD.

AND THAT'S LIVING."

— URSULA ANDRESS

Ursula Andress and cat, c. 1965.

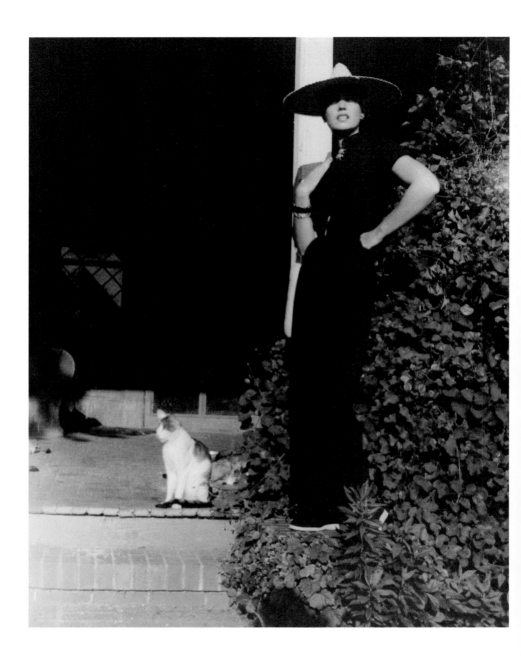

ABOVE: Edith "Little Edie" Bouvier Beale with cat at Grey Gardens, 1951.

RIGHT: Adolf Pirsch, Austrian, 1859–1929. *Bildnis einer Dame mit Katze (Portrait of a Lady with Cat)*, c. 1900, oil on canvas.

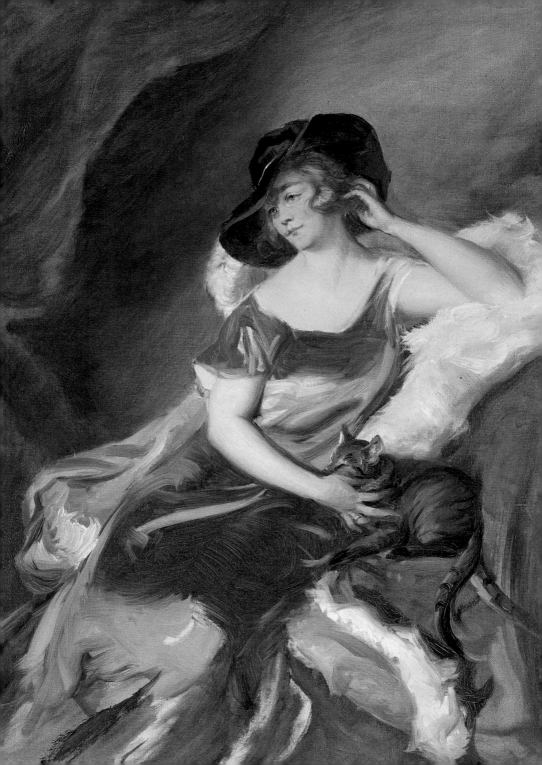

BELOW: Jacqueline Bouvier Kennedy
with Caroline Kennedy and two
cats, Hyannis Port, Massachusetts,
summer 1960. Photograph by
Jacques Lowe.

RIGHT: Natalie Wood and cat, from
the film *Peeper*, 1976.

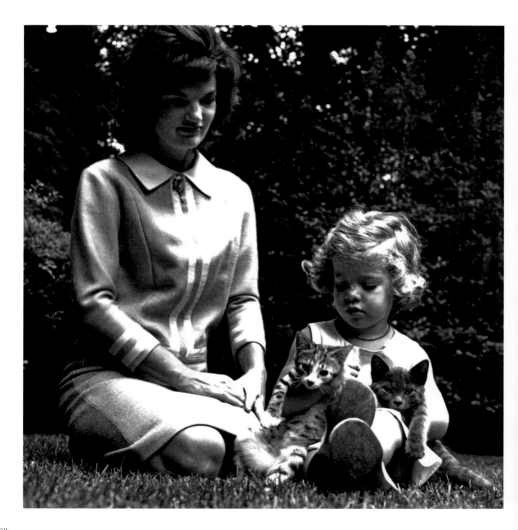

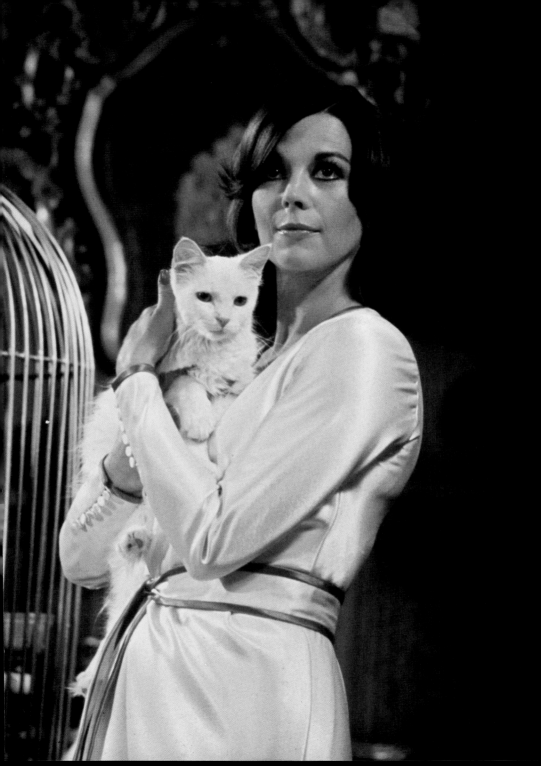

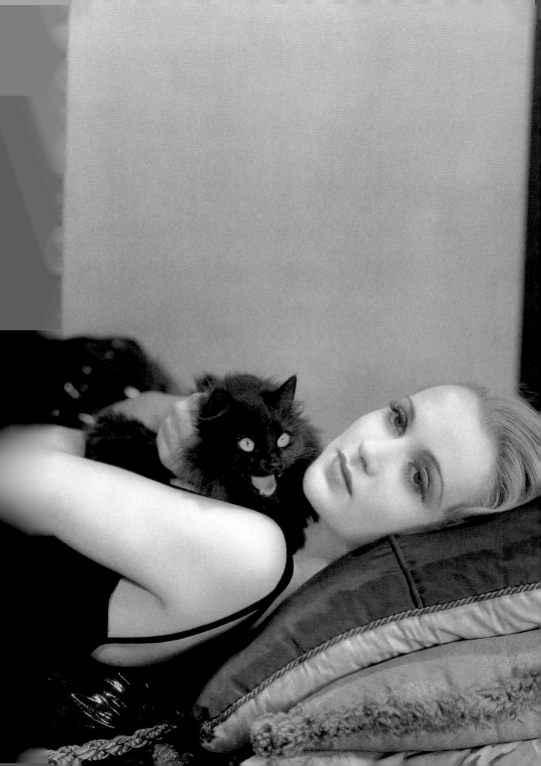

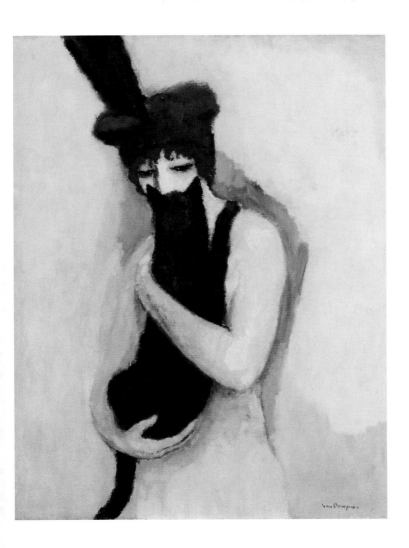

LEFT: Carole Lombard and cat, c. 1935.

ABOVE: Kees van Dongen, Dutch, 1877–1968. *Woman with Cat*, 1908, oil on canvas.

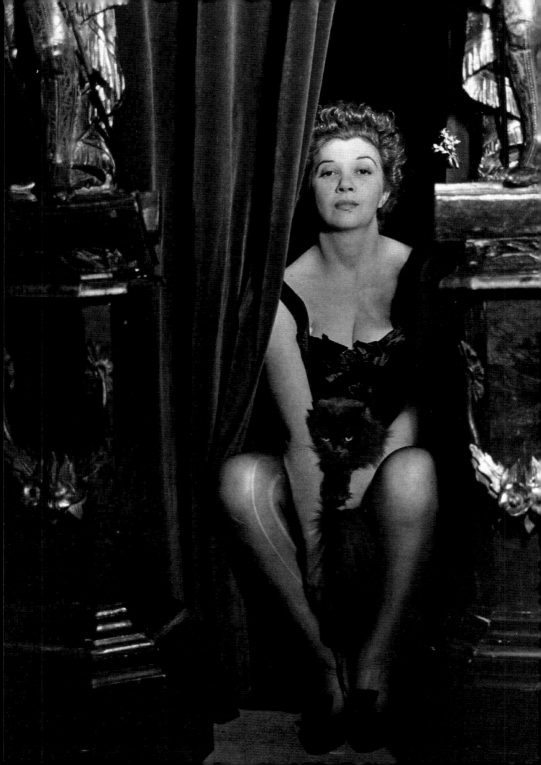

"IN EVERY WAY, CATS ARE THE MOST

PERFECT CREATURES ON THE

FACE OF THE EARTH, EXCEPT THAT

THEIR LIVES ARE TOO SHORT."

—LEONOR FINI

Leonor Fini and cat, 1936. Photograph by Dora Maar.

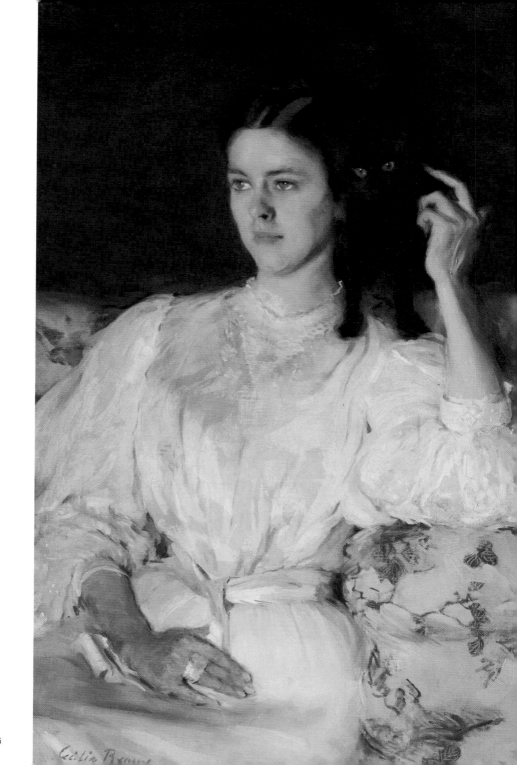

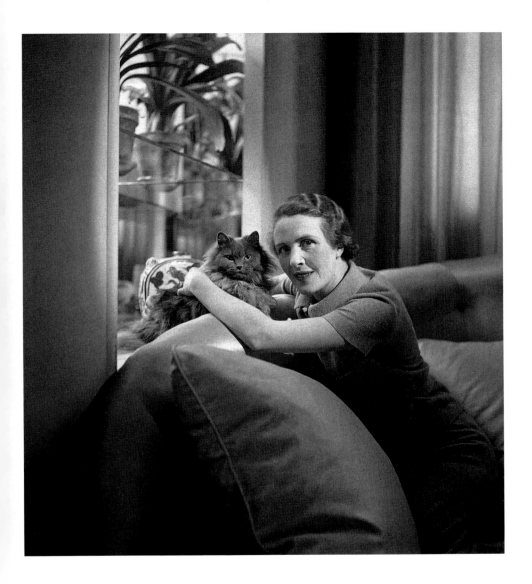

LEFT: Cecilia Beaux, American, 1855–1942. *Sita and Sarita*, 1893–94, oil on canvas.

ABOVE: Countess Marie-Blanche de Polignac with her cat, France, 1934. Photograph by Boris Lipnitzki.

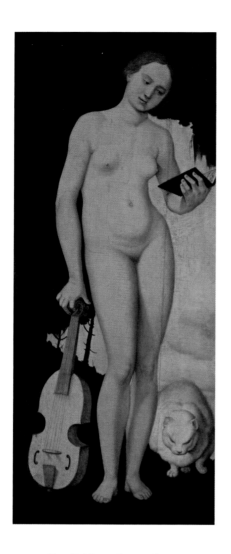

ABOVE: Hans Baldung, German, born 1484 or 1485, died 1545. *Allegorical Figure of a Woman with Musical Book, Viola and Cat*, 1529, limewood.

RIGHT: Maya Deren and cat, from *In the Mirror of Maya Deren*, 2002.

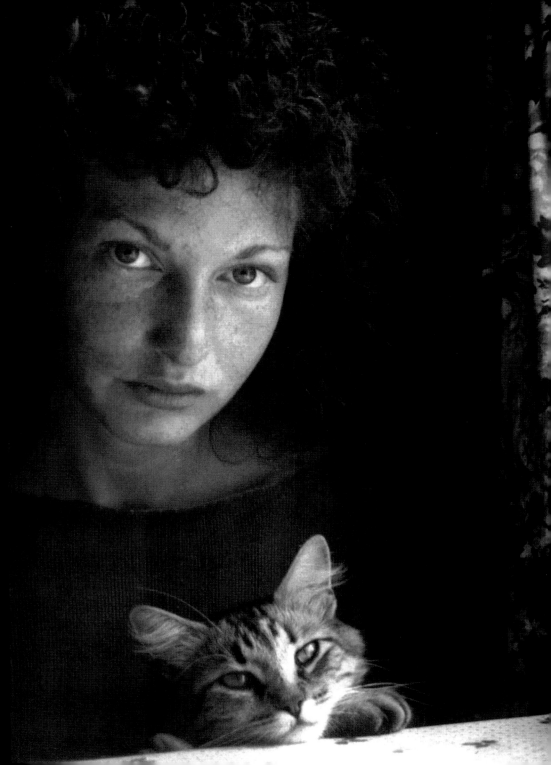

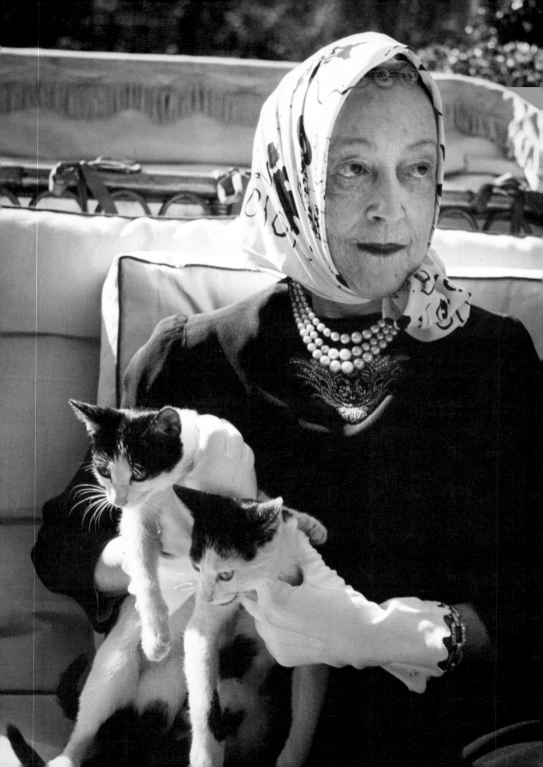

LEFT: Elsie de Wolfe (Lady Mendl)
and two cats, Paris, 1946. Photograph
by Louise Dahl-Wolfe.

BELOW: P. B. Hickling, English,
1876–1951. *Addition and
Subtraction*, 1926, illustration.

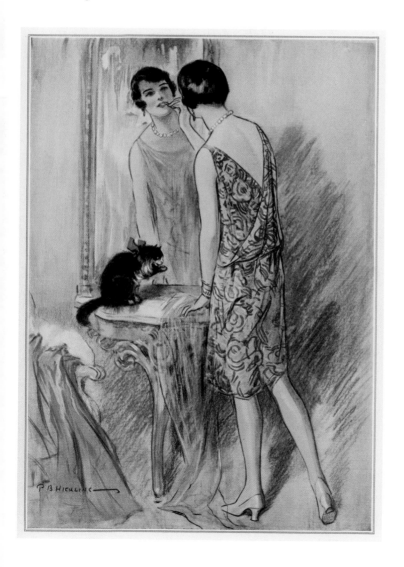

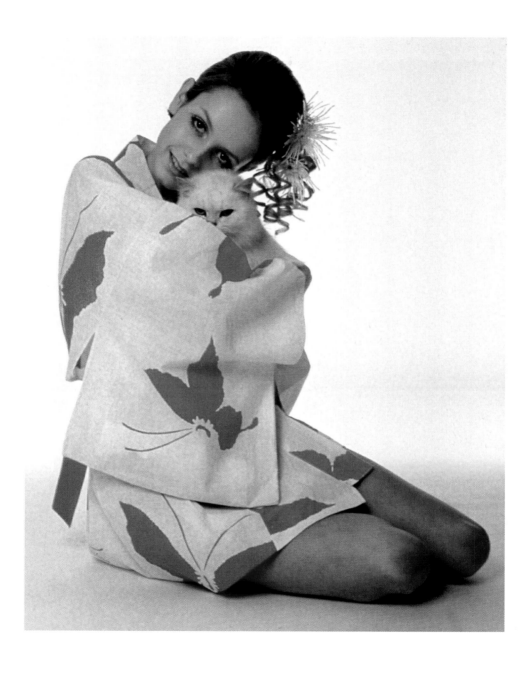

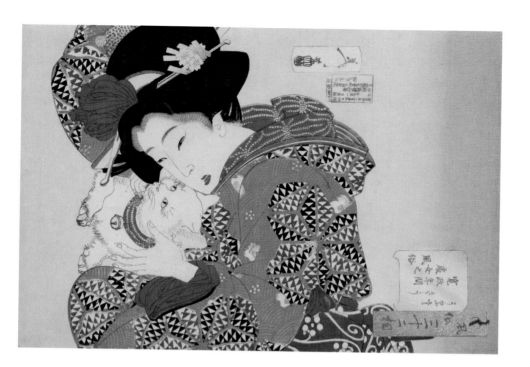

LEFT: "Twiggy Geisha," from *Mlle Âge Tendre* magazine, 1968.

ABOVE: Tsukioka Yoshitoshi, Japanese, 1839–1892. *Looking Troublesome—The Appearance of a Virgin of the Kansei Era*, 1888, color woodblock print.

"SOCKS, ESPECIALLY,

LIKES TO POSE FOR PICTURES."

— HILLARY CLINTON

First Lady Hillary Clinton and Socks, 1995.

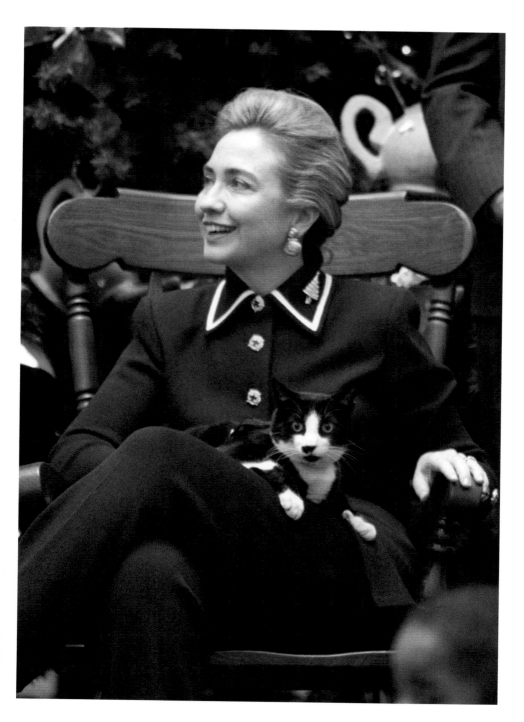

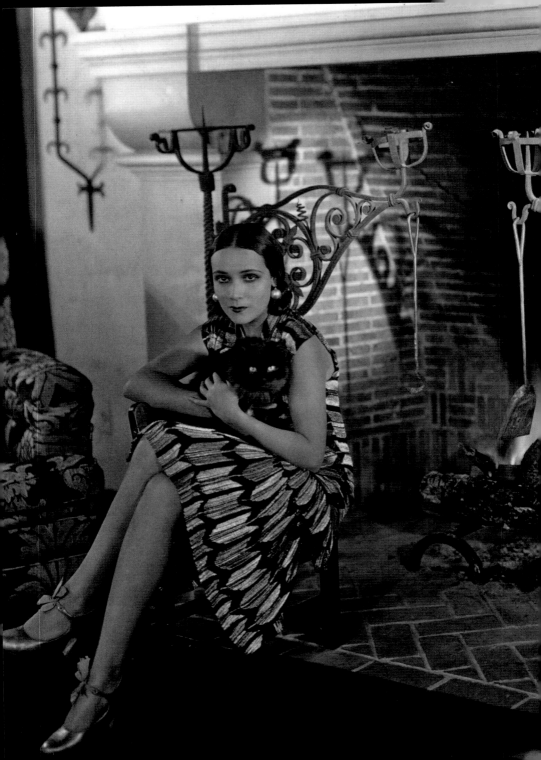

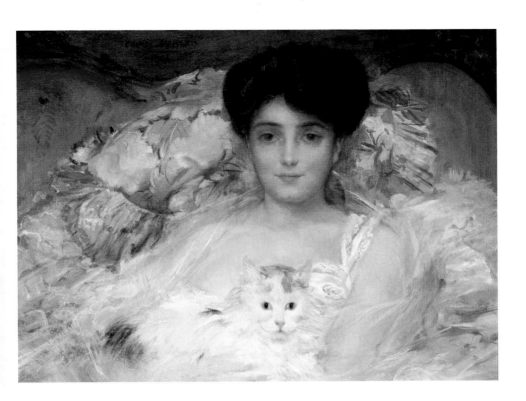

ABOVE: Charles Massard, French,
1871–1913. *Lady with a Cat*, 1904,
oil on canvas.

LEFT: Dolores del Rio and her cat,
Joan, c. 1935.

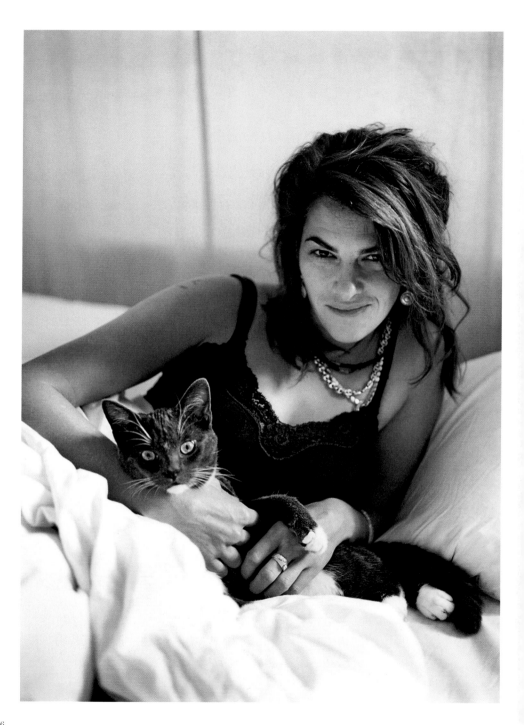

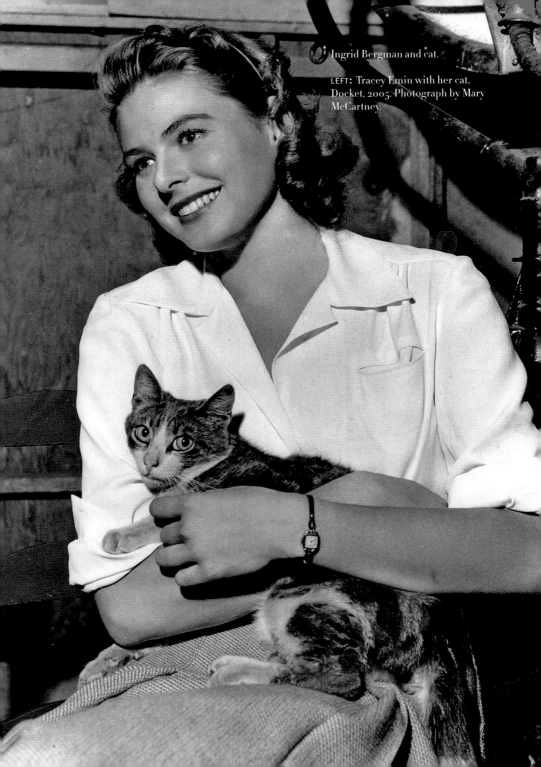

Ingrid Bergman and cat.

LEFT: Tracey Emin with her cat, Docket, 2005. Photograph by Mary McCartney.

RIGHT: Halle Berry and cat, from the film *Catwoman*, 2004.

BELOW: Lena Horne with kitten. Photograph by Florence Homolka.

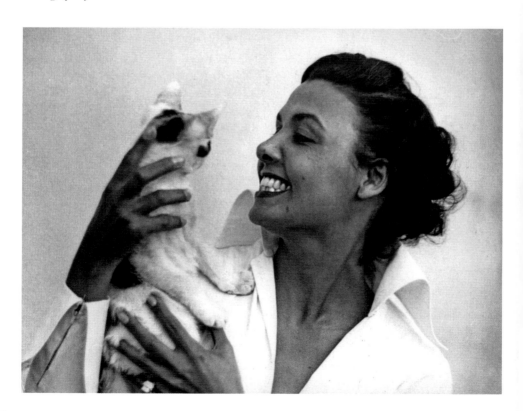

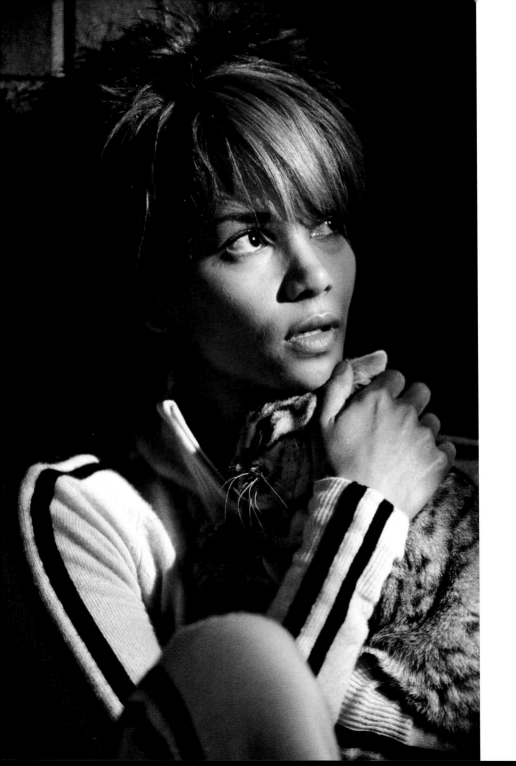

"I HAVE AN OPTIMISTIC
ATTITUDE. WHEN I GET UP IN THE
MORNING, I FIRST OF ALL MAKE
THE COFFEE AND THEN
I SAY TO MY CAT, 'WE'RE GOING
TO HAVE A GREAT DAY.'"

— PATRICIA HIGHSMITH

Patricia Highsmith and Siamese cat.

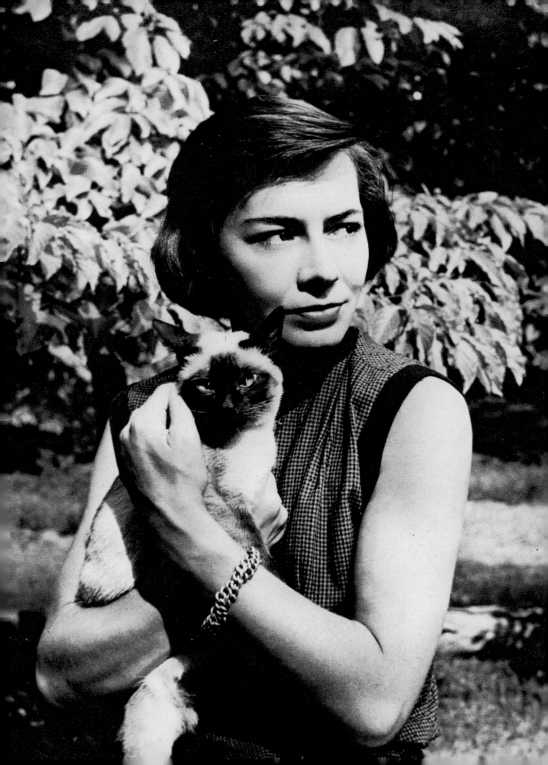

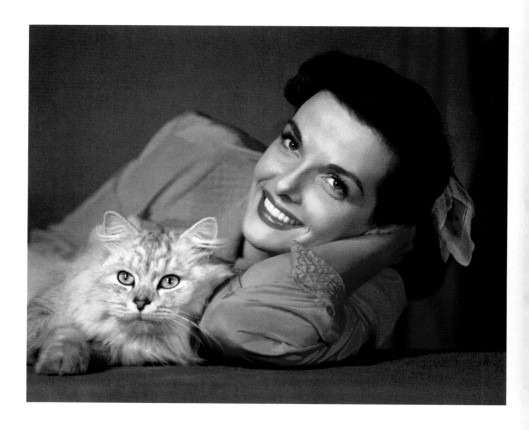

ABOVE: Jane Russell and cat.

RIGHT: Georgia O'Keeffe and cat,
New Mexico, c. 1935. Photograph by
John S. Candelario.

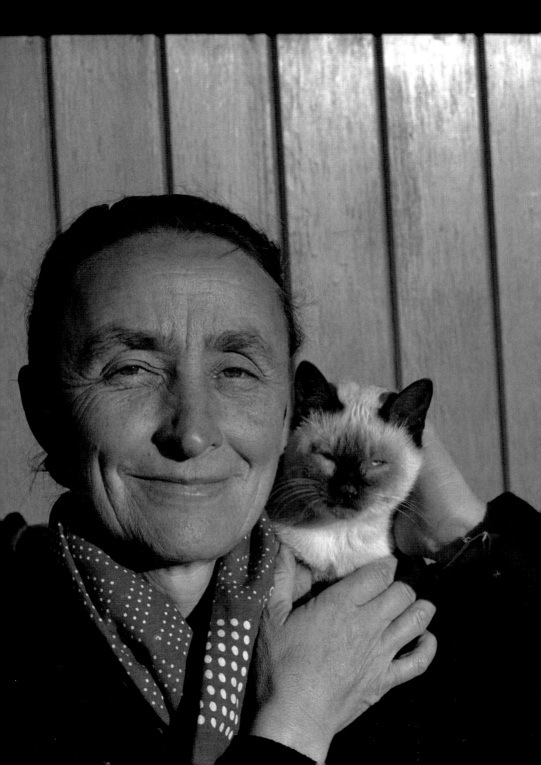

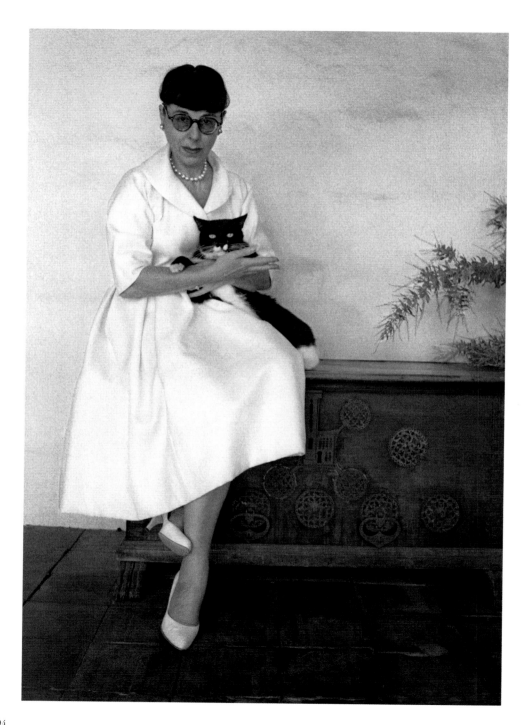

LEFT: Edith Head and cat.
Photograph by Bob Willoughby.

BELOW: Francesco Bacchiacca, Italian,
1494–1557. *Portrait of a Young Lady
Holding a Cat*, 1525, oil on panel.

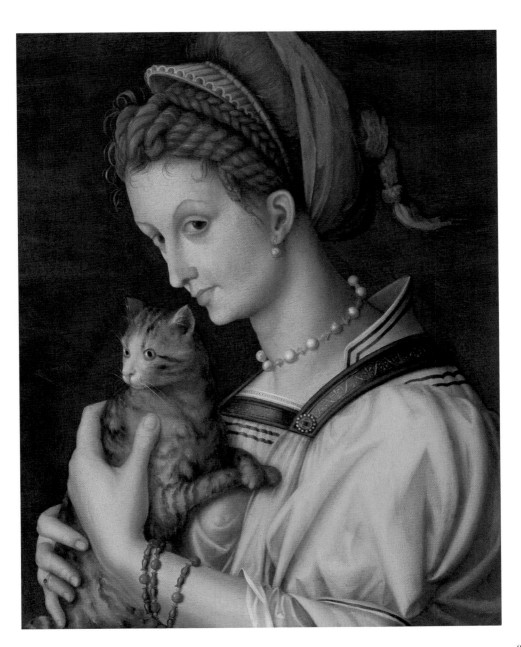

Alexandre Cabanel, French, 1823–1889.
Cleopatra Testing Poisons on Those Condemned
to Death, 19th century, oil on canvas.

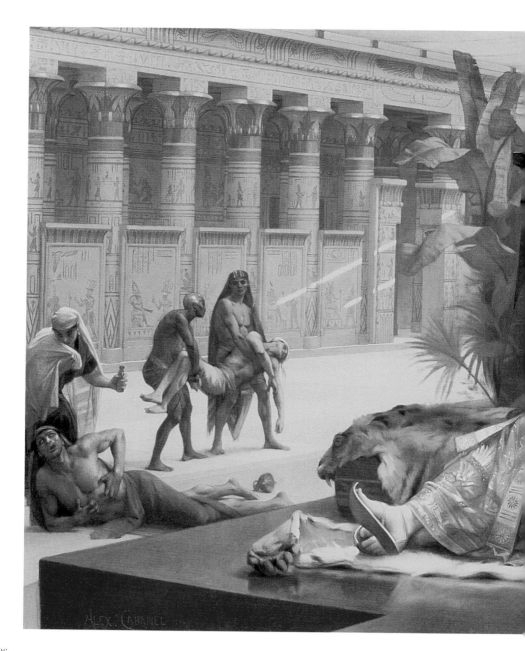

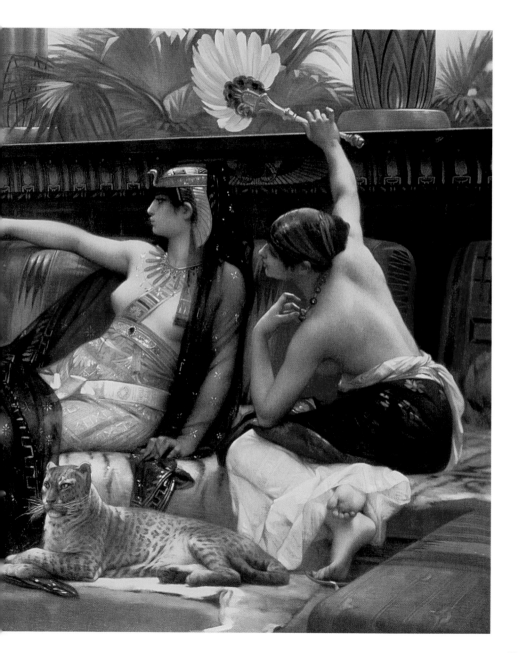

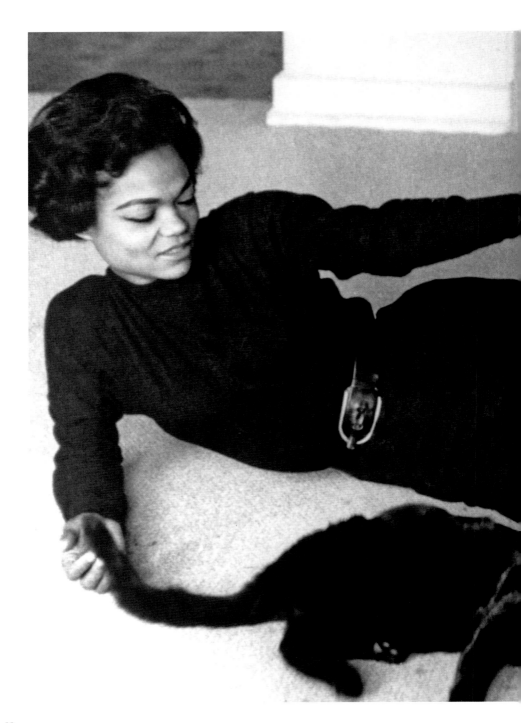

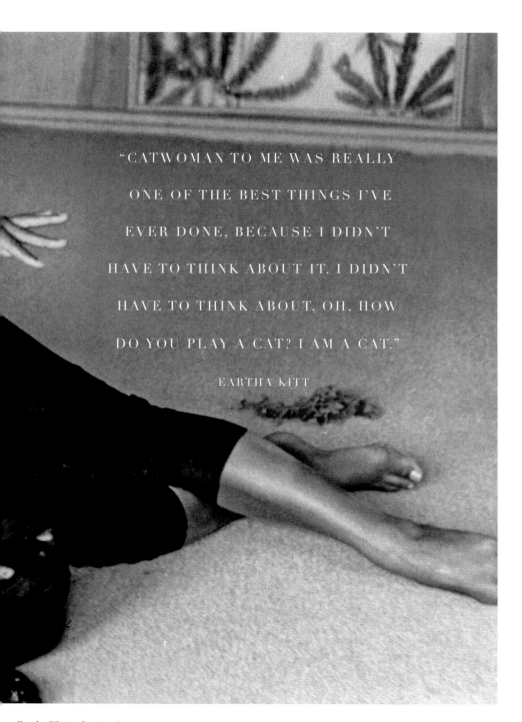

"CATWOMAN TO ME WAS REALLY ONE OF THE BEST THINGS I'VE EVER DONE, BECAUSE I DIDN'T HAVE TO THINK ABOUT IT. I DIDN'T HAVE TO THINK ABOUT, OH, HOW DO YOU PLAY A CAT? I AM A CAT."

EARTHA KITT

Eartha Kitt and cat, 1960s.

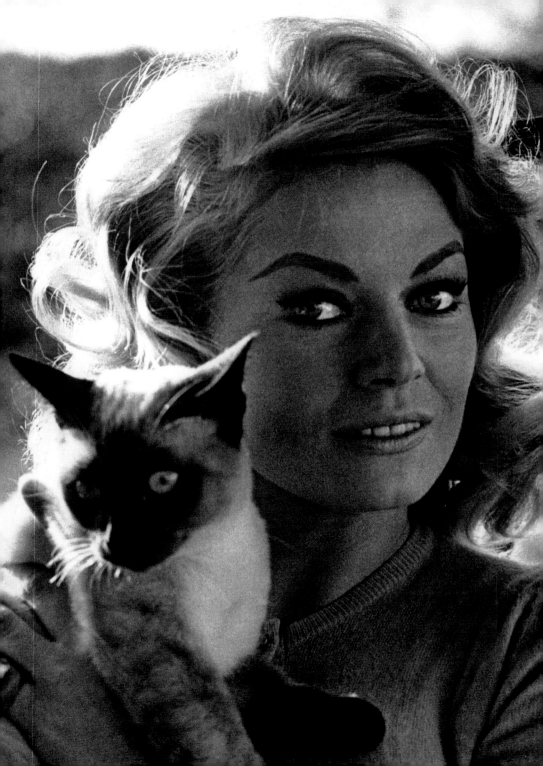

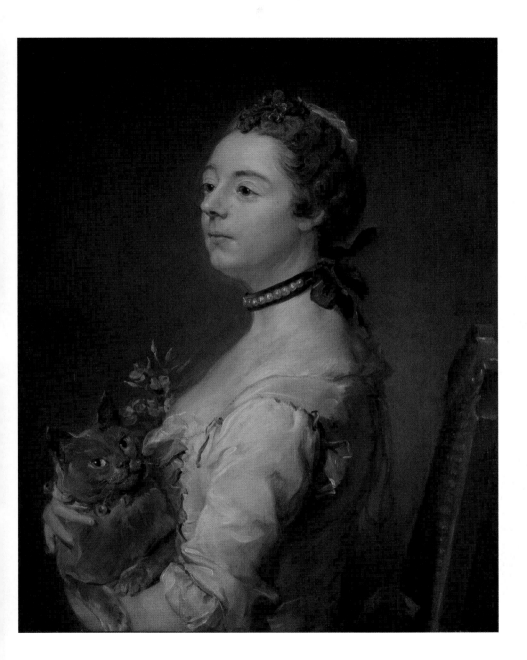

LEFT: Anita Ekberg and cat, 1966. Photograph by Pierluigi Praturlon.

ABOVE: Jean-Baptiste Perronneau, French, c. 1715–1783. *Magdaleine Pinceloup de la Grange, née de Parseval*, 1747, oil on canvas.

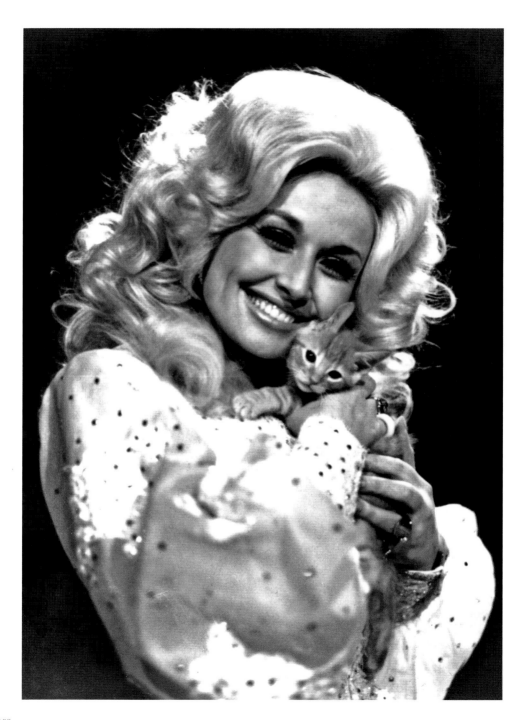

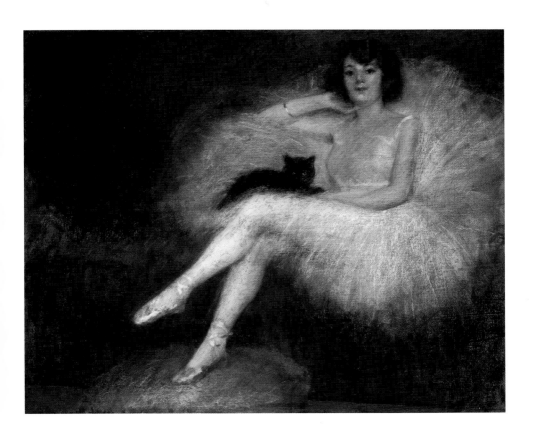

Lauren Pears and cat, 2013.
Photograph by Ki Price.

RIGHT: Romy Schneider and cat, from
the film *What's New Pussycat?*, 1965.

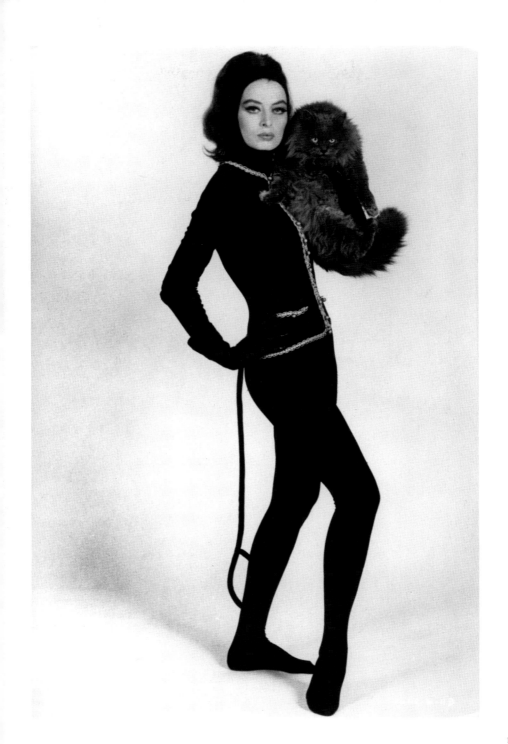

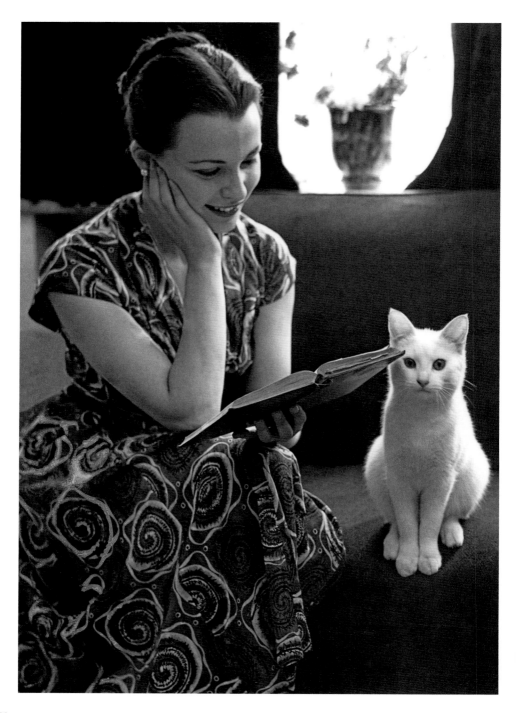

LEFT: Claire Bloom and cat, 1951.

BELOW: Walter Crane, British,
1845–1915. *At Home: A Portrait*, 1872,
tempera on paper.

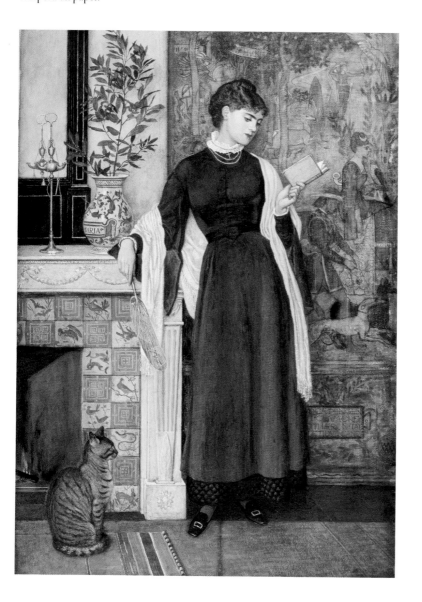

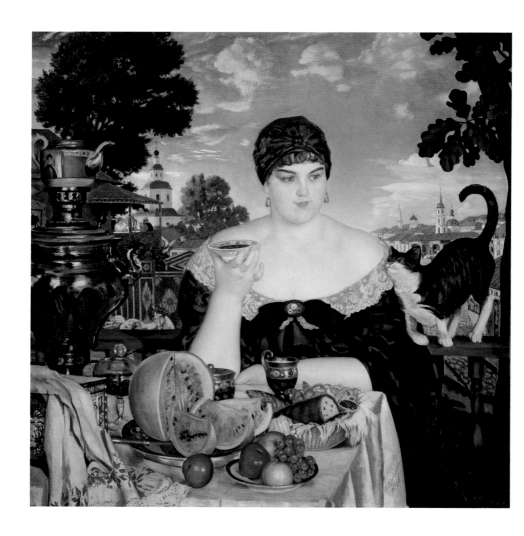

ABOVE: Boris Mihajlovic Kustodiev,
Russian, 1878–1927. *The Merchant's
Wife at Tea*, 1918, oil on canvas.

RIGHT: Jean Harlow and Persian cat.

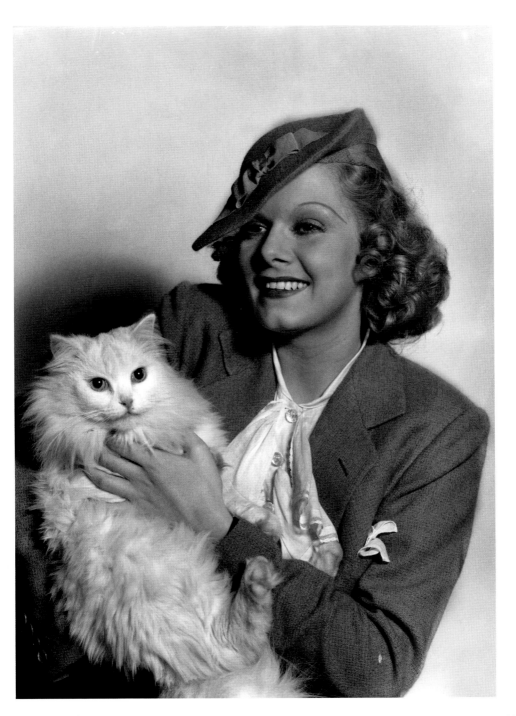

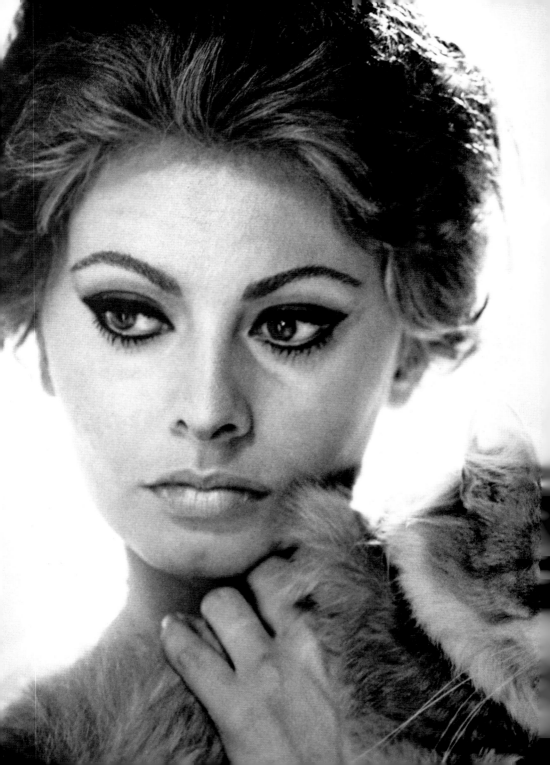

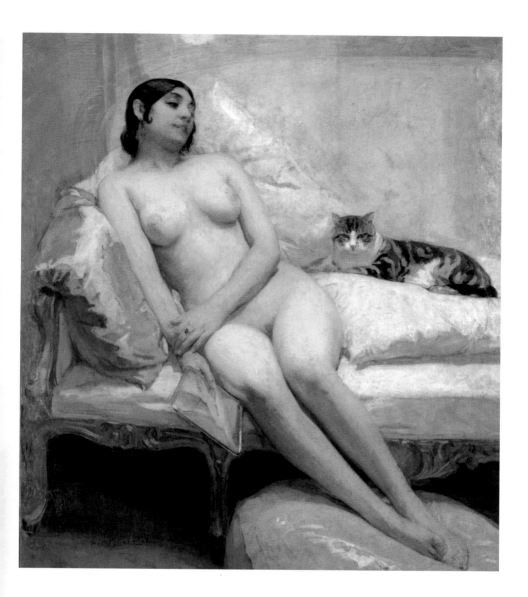

LEFT: Sophia Loren and cat, from the
film *Yesterday, Today, and Tomorrow
(Ieri, oggi, domani)*, 1963.

ABOVE: Anselmo Miguel Nieto,
Spanish, 1881–1964. *Desnudo del gato
(Nude with Cat)*, undated,
oil on canvas.

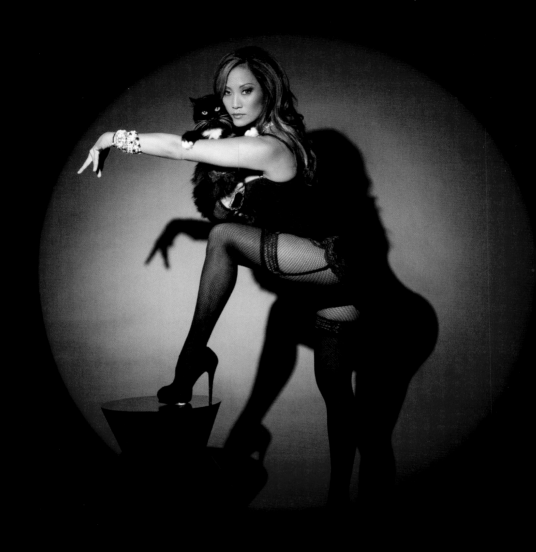

Carrie Ann Inaba and Shadow.
Photograph by Robert Sebree.

RIGHT: Zelda Fitzgerald and cat,
c. 1928–30.

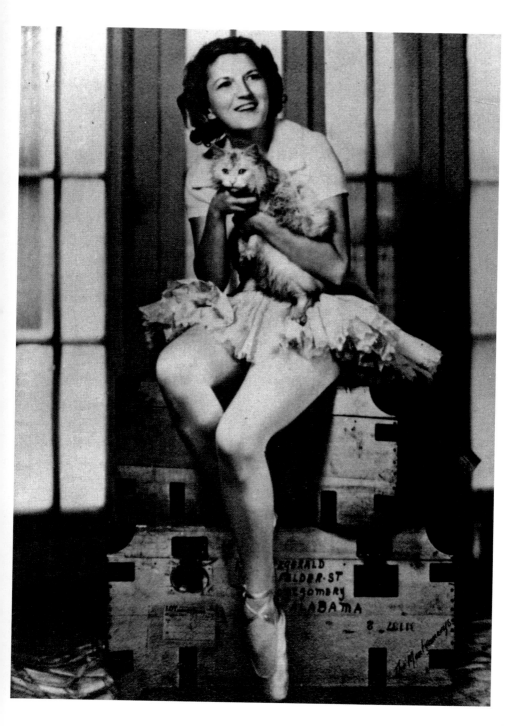

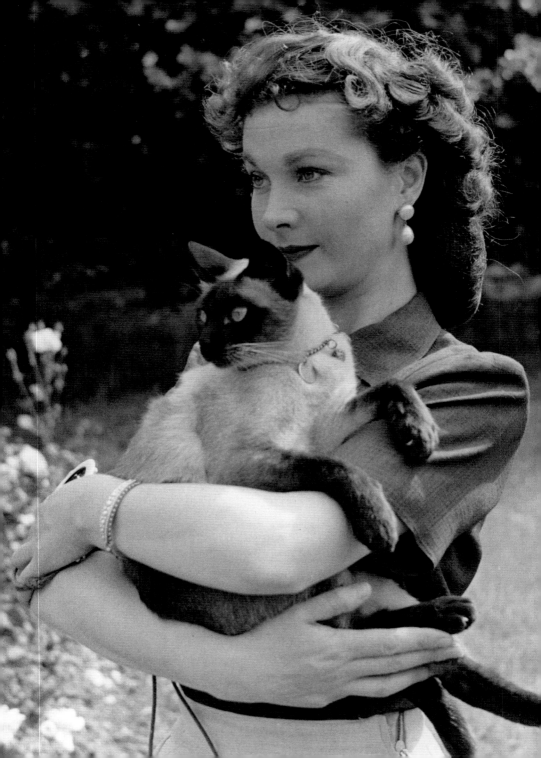

"I HAVE ALWAYS BEEN

CRAZY ABOUT CATS."

—VIVIEN LEIGH

Vivien Leigh and Siamese cat, 1950s. Photograph by Leslie Baker.

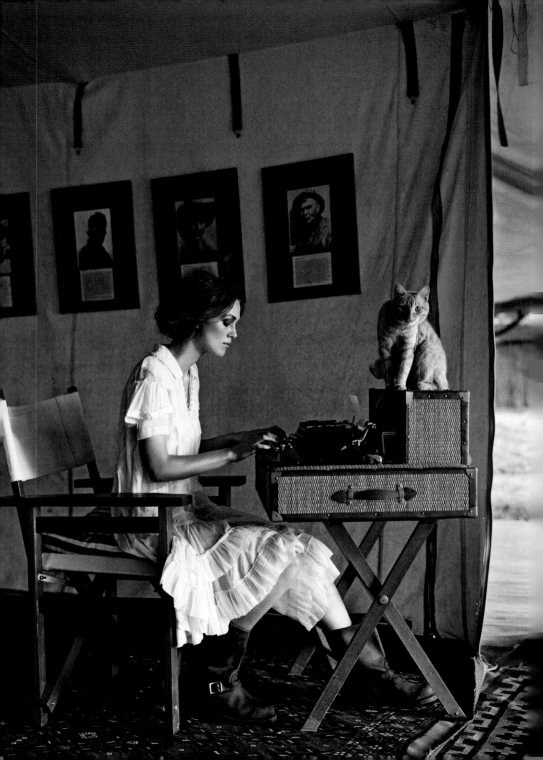

LEFT: Keira Knightley and cat.
Photograph by Arthur Elgort.

BELOW: Louise Nevelson and cat,
c. 1970. Photograph by Geoffrey
Clements.

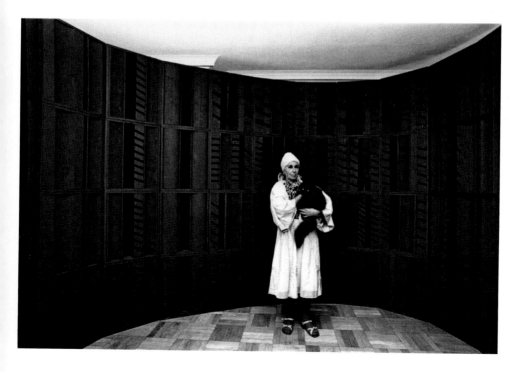

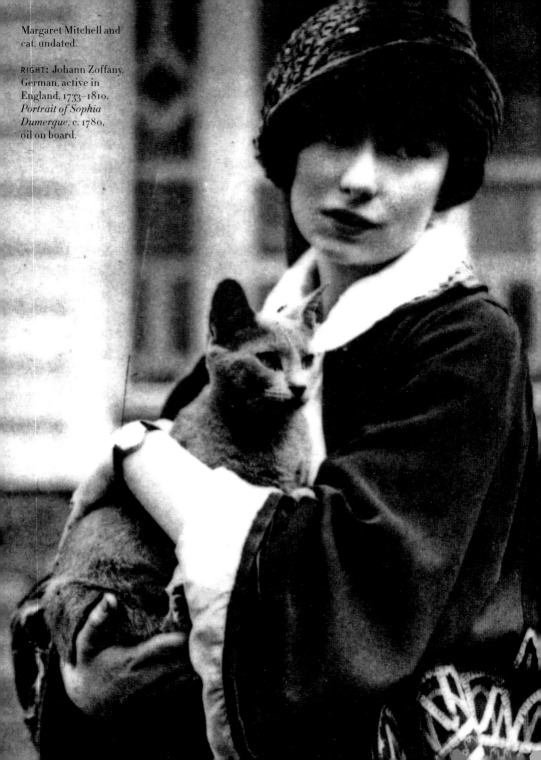

Margaret Mitchell and cat, undated.

RIGHT: Johann Zoffany, German, active in England, 1733–1810. *Portrait of Sophia Dumergue*, c. 1780, oil on board.

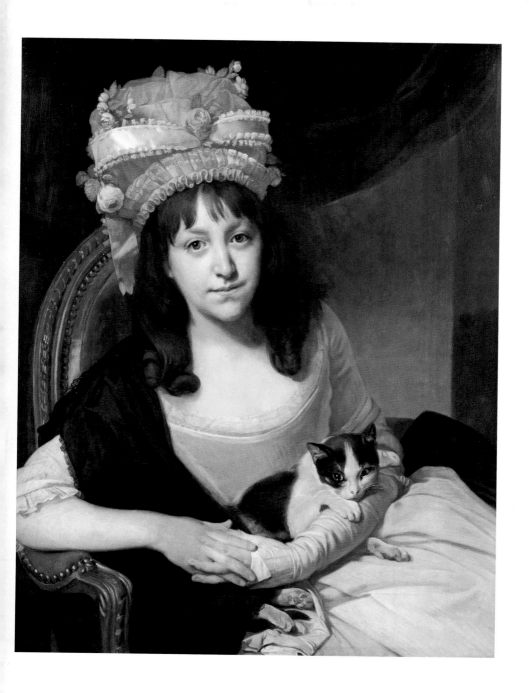

Ann Sheridan and cat.

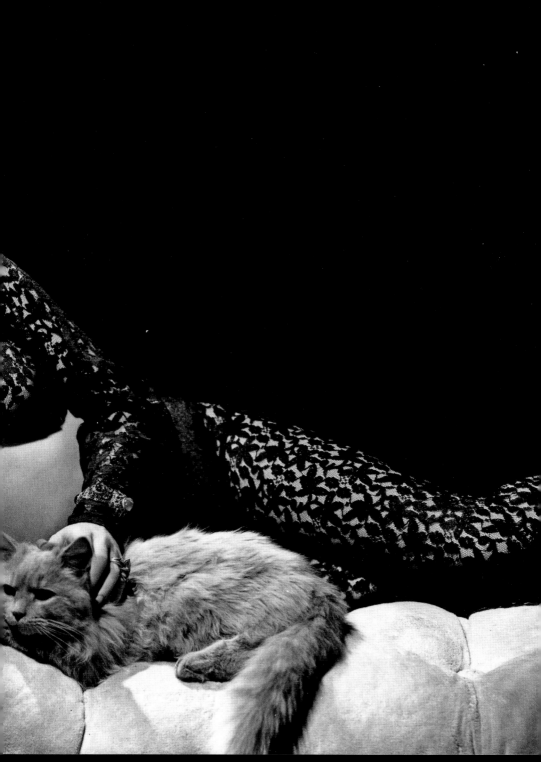

PHOTO CREDITS

Page 11: Columbia/The Kobal Collection at Art Resource, NY

Page 12: Silver Screen Collection/Moviepix/Getty Images

Page 13: Photograph taken for *Look* magazine Shorpy

Page 14: The Kobal Collection at Art Resource, NY

Page 15: Courtesy of the Cecil Beaton Studio Archive at Sotheby's

Page 16: Photograph taken for Paramount Paramount/Howell Conant/The Kobal Collection at Art Resource, NY

Page 18: Photofest

Page 19: Photograph taken for *Vogue* © Condé Nast

Page 20: Österreichische Nationalbibliothek

Page 21: ullstein bild/The Granger Collection, New York

Page 22: Mary Evans Picture Library/National Magazine Company

Page 23: © 2013 *The New York Times Magazine*

Page 24: Paramount/The Kobal Collection at Art Resource, NY

Page 25: © Sanford Roth/A.M.P.A.S./mptvimages.com

Page 26: Everett Collection

Page 27: © Condé Nast

Page 29: Guy Reno/BtooB/eyevine/Redux

Page 30: ullstein bild/The Granger Collection, New York

Page 31: Sam Levin/Camera Press London

Page 32: © Laura Levine

Page 33: Tate Gallery, London. Photograph © 2013 Tate, London

Page 34: Library of Congress Prints and Photographs Division, Washington, D.C. Courtesy of the Library of Congress, LC-G432-1584-A

Page 35: Hedda Sterne papers, Archives of American Art, Smithsonian Institution © Estate of Evelyn Hofer

Page 36: Photofest

Page 37: Ellen von Unwerth/Trunk Archive

Page 38: © The Museum of Fine Arts, Houston, the Garth Clark and Mark Del Vecchio Collection, museum purchase funded by the Caroline Wiess Law Accessions Endowment Fund; photograph courtesy The Museum of Fine Arts, Houston

Page 39: Photograph by Madame Yevonde © Yevonde Portrait Archive/ILN/Mary Evans Picture Library

Page 40: Photofest

Page 42: Rue des Archives/The Granger Collection, New York

Page 43: Photograph © VAN HAM/Fuis Photographie Köln

Page 44: Photograph taken for *Vogue* © Condé Nast

Page 45: Photograph by Edward Steichen © Condé Nast

Page 46: Photograph taken for Paramount publicity © United Archives/Topfoto/The Image Works

Page 47: Fitzwilliam Museum, University of Cambridge, UK/The Bridgeman Art Library

Pages 48–49: Arthur Schatz/Time & Life Pictures/Getty Images

Page 50: © 2002 Enrico Ferorelli

Page 51: RKO Radio Pictures/Photofest © RKO Radio Pictures

Page 53: Musée d'Art Moderne Richard Anacreon, Granville, France/Archives Charmet/The Bridgeman Art Library

Page 88: Courtesy Keith de Lellis Gallery © Estate of Florence Homolka

Page 89: Warner Bros./DC Comics/The Kobal Collection at Art Resource, NY

Page 91: Swiss Literary Archives, Bern, Switzerland

Page 92: Photofest

Page 93: Palace of the Governors, Santa Fe, New Mexico

Page 94: © Bob Willoughby/www.mptvimages.com

Page 95: Private collection. Photograph © Christie's Images/The Bridgeman Art Library

Pages 96–97: Koninklijk Museum voor Schone Kunsten, Antwerp, Belgium/The Bridgeman Art Library

Page 98–99: Everett Collection

Page 100: Pierluigi Praturlon/Mondadori Portfolio via Getty Images

Page 101: The J. Paul Getty Museum. Digital image courtesy the Open Content Program at The J. Paul Getty Museum

Page 102: © REX USA/CSU Archv/Everett Collection

Page 103: Private collection. Photograph © Christie's Images/The Bridgeman Art Library

Page 104: © Ki Price

Page 105: British Film Institute

Page 106: © TopFoto/The Image Works

Page 107: Leeds Museums and Galleries (Leeds Art Gallery), U. K. /The Bridgeman Art Library

Page 108: State Russian Museum, St. Petersburg, Russia/Giraudon/The Bridgeman Art Library

Page 109: Photofest

Page 110: The Granger Collection, New York

Page 111: Private collection, Madrid Album/Art Resource, NY

Page 112: © SebreePhoto.com

Page 113: Everett Collection/Mondadori Portfolio (AA306189)

Page 114: Leslie Baker/Camera Press London

Page 116: Photograph taken for *Vogue* © Condé Nast

Page 117: Louise Nevelson papers, Archives of American Art, Smithsonian Institution © Geoffrey Clements

Page 118: Atlanta History Center, Georgia Kenan Research Center at the Atlanta History Center

Page 119: © Victoria Art Gallery, Bath and North East Somerset Council/The Bridgeman Art Library

Pages 120–21: Photofest

Page 126: Image courtesy Virág Judit Galéria

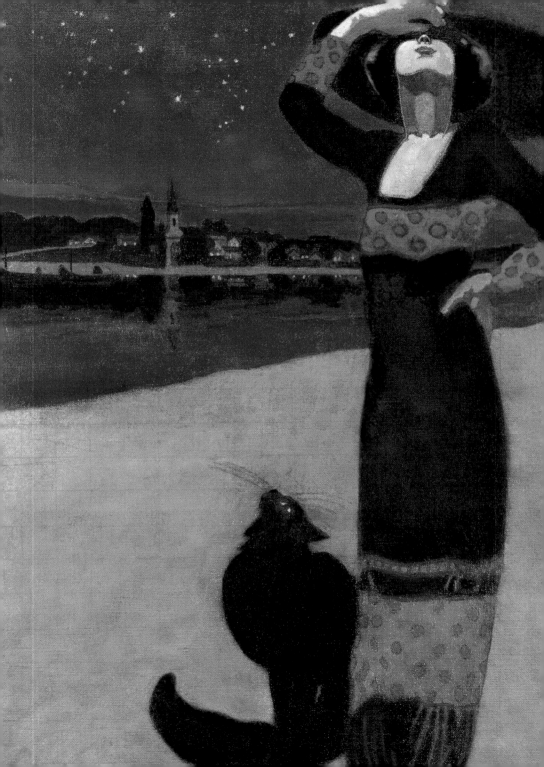

ACKNOWLEDGMENTS

I am very grateful to Lyn DelliQuadri, my longtime friend and former boss at the Art Institute of Chicago, and Jane Lahr for agreeing to serve as my agents for *Cat Lady Chic*. They championed this project early on and provided expert guidance every step of the way. David Cashion, who admitted at the outset to being a dog lover, did not need to convince me that he was the perfect editor for this book, in which the cat is the top dog. It has been a true privilege to collaborate with David and the exceptional team at Abrams Image, and I also want to thank Deborah Aaronson, vice president and publisher. Rachel Willey thoughtfully designed a book that combines elements of timeless and contemporary chic.

Marty Stein and Kem Schultz were extremely collegial, and I could not have produced this book without the astute assistance of Margaret McKee, a professional image librarian who freelanced as my photo editor before and after office hours. Heather Brand, a close friend and fellow cat lover, offered to read my introductory essay at various stages and to review pull quotes from some of the famously opinionated Cat Ladies featured in this book.

I thank especially my mother, my husband, and my furry kids. Finally, I wish to dedicate this book to Lucius, who is forever in my memories. I hope he considered his Cat Lady chic.

Géza Faragó, Hungarian,
1877–1928. *Slim Woman with
a Cat*, 1913, oil on canvas.

EDITOR: David Cashion
DESIGNER: Rachel Willey
PRODUCTION MANAGER: Erin Vandeveer

Library of Congress Control Number: 2014930728

ISBN: 978-1-4197-1402-3

Printed and bound in the United States.
10 9 8 7 6 5 4 3 2 1

Abrams Image books are available at special discounts when purchased in quantity for premiums and promotions as well as fundraising or educational use. Special editions can also be created to specification. For details, contact specialsales@abramsbooks.com or the address below.

THE ART OF BOOKS SINCE 1949

115 WEST 18TH STREET
NEW WORK, NY 10011
WWW.ABRAMSBOOKS.COM